FORT COLLINS
BEER

A HISTORY OF BREWING ON THE FRONT RANGE

BREA D. HOFFMAN

FOREWORD BY JOSHUA B. HALL

AMERICAN PALATE

Published by American Palate
A Division of The History Press
Charleston, SC
www.historypress.net

Copyright © 2017 by Brea Hoffman
All rights reserved

Front cover: Ryan Burke.
Back cover, top: Fort Collins History Collection; *bottom*: Gus Hoffman.

First published 2017

ISBN 9781540216786

Library of Congress Control Number: 2017931808

Contents

Foreword

I've traveled the country drinking beer in an abundance of places, spent countless dollars on beers that I've not even opened yet and took vacations centered on visiting breweries. I've been wowed by their beers and charmed by their locals, but no place captures my heart like Fort Collins, Colorado. That's why I sit here now, in my home in Old Town Fort Collins, drinking a Fort Collins brew, excited to bring you this historical jaunt about a remarkable town where beer really does make the world go 'round. Aside from my southern drawl and affinity for pastel or pearl snap button-up shirts rather than flannel, I look like and may be the quintessential Colorado beer drinker. You'll often find remnants of the head of a freshly poured IPA in my beard, or my nose deep in a snifter of brew. I bike around town. I drive my Subaru when I want to head west into the mountains. I work at a brewery, lucky enough to play an integral part in our daily operations. I'm privileged to taste our beers throughout the entire brewing process so that I can write our beers' descriptions. Every semester I am asked to speak to classes at Colorado State University, enlightening upper and lower classmen alike on what may lie ahead for them. Recently, I was asked to lend my knowledge as the "beer expert" for a five-course pairing dinner put on by our local newspaper, the *Coloradoan*. This year, at the Great American Beer Festival, I gave a presentation, with food pairings, on how salt enhances the flavors of beer. I truly do live, breathe and love beer.

When I first spoke with Brea about this project, I was captivated by her passion for the Fort Collins beer scene. Beyond that, I was fascinated

by her desire to tell the beer story of this town I call home. That afternoon, she was belly-up to the bar, with a few taster glasses in front of her, smile wide, ready to discuss this purposeful venture. As we dove into what stoked that desire, she reminisced fondly about college days at CSU and the excitement of learning that the neighborhood party had gotten its hands on a keg of Sunshine Wheat instead of the old standby Natural Light. It brought me back to my move here from Georgia more than a decade ago, in pursuit of the "Choice City." I was reminded of the feeling of removing that final item from the U-Haul trailer and sitting down with a cold, well-deserved ale from what I could now call my neighborhood brewery. The more Brea told me about this book, the greater my excitement. Finally, someone was going to tell the story, put together the tales and recall the beer history of this town, this mecca, this utopia of brewing culture. Want to know about the bike ride that changed American beer? Want to know how someone's several failed attempts at gaining employment in a Pacific Northwest brewery helped to set off a chain of events that led to one of the best breweries in America? Was Fort Collins really without alcohol for nearly seventy-five years? You'll read about that and more as you learn the story of how your favorite Fort Collins establishments came to life—the history, the beers, the people, the culture and the future. Tales and anecdotes make up this historical and comprehensive narrative of the beers and breweries that helped reshape Fort Collins from a quaint college town to the international beer destination it is today. It's all here, from Anheuser-Busch to Zwei.

Now that you know what lies ahead, are you ready? You will be eloquently whisked through time, from the first liquor establishment in 1875 to the quickly mismanaged alcohol regulations that followed, from the onset of the craft beer revolution more than two decades ago to the nearly two dozen breweries in town today. What you have in your hands (aside from, hopefully, a beer) is an in-depth look at events, people and beers that changed the scope of a particular sleepy town in northern Colorado that has grown into what many refer to as the "Napa Valley of Beer." Dip your nose into that glass, take in that beautifully and deliciously crafted beverage and set sail on the liquid journey that is the history of the world's greatest beverage, in what just might be the world's greatest town.

Joshua B. Hall,
Brand Ambassador, Fort Collins Brewery,
October 2016

Acknowledgements

Ever since I learned to read, I have been fascinated with language and literature. As I grew, I dreamed of someday being a published author. At the time, the expression of that was vague, and I think it's fair to say that in my teens I never thought I could make booze a career, much less write about it. Twenty years later, I have been given an incredible gift and opportunity. First and foremost, I thank my husband, Gus Hoffman. He has been my principle photographer, production assistant, counselor and greatest champion. This book, and my dream, would not have been realized without him. At the risk of getting sappy, it is a rare moment to realize that a partnership with another person has literally made your dreams come true.

I want to thank the people who helped develop my knowledge of beer. It may sound strange, but my beer career started with wine. With that in mind, I must thank Brandy Mannix, my wine instructor and one of my best friends. She developed my palate and made me think critically about libations. With that confidence, I left "safe" employment and chased my weird dreams. When I moved into the field of beer, I had no credentials. But Amber Lyman believed enough in my palate to teach me the way of the suds. Thanks for believing, Amber. Thanks to the beautiful beer mavens I have worked alongside, in no particular order: Jackie Miller, Amber Hamilton, Gina Lechuga, Katie Krieger, Katie McNeal, Jae Drouilhet, Becky Westnidge, Ana Hawn, Shanna Greenleaf and Jill Crowley. In some cases, I taught you about beer; in all cases, you taught me.

ACKNOWLEDGEMENTS

This opportunity would not have been possible without Simone FM Spinner. She is one of my greatest wine mentors. Had it not been for her belief in me, paired with her tapping my inner beer geek, I would have never known about this publisher. Thank you to The History Press for this tremendous opportunity. My editor, Candice Lawrence, has held my hand with unwavering encouragement for every step of this process. At times I felt lost and ill equipped. She carefully walked me through the landmines, both real and imagined.

Thank you to my parents, David Engleman and Chris Kilmer, the original cheerleaders. Thank you for reading to me, teaching me and always telling me I could be anything I wanted. Thanks for believing it, too.

Thanks to Rich English and Nick Plumber for being good friends and writing inspirations. Thanks to the crew at Tooey's, on both sides of the bar, for letting me wax poetic about libations after I'd had more than a few.

I would be remiss without thanking the incredible people in the Fort Collins brewing scene for their time and information: Carol Cochran, Doug Odell, Bryan Simpson, Brad Lincoln, Tina Peters, Brandon Neckel, Francesca Dreith, Kirk Lombardi, Marni Wahlquist and so many others. I offer special mention to Josh Hall for writing the foreword. You all are the inspiration for this book. You are a part of a culture and beer scene that the world must know about. I owe you a debt that I can only hope to pay by sharing your stories.

Introduction

Every day, all of us face challenges: the 9:00 a.m. Monday presentation; balancing three kids, six activities and one very busy afternoon maneuver ("Hey, what's for dinner?"); working an internship to break into a field, wondering how you'll pay the rent with "a really valuable experience"; spending the day being composed and decisive at work, only to go home thinking you have no idea what you are doing. Being an adult is hard. Beer is our reward.

Beer is a science and an art. It is the sigh of relief after a day that makes you question your journey. It is celebratory and the lifeblood of great conversation, policy and, sometimes, revolution. America's beer history runs parallel to its origins and development—a country of immigrants who brought a taste of their homeland to the land of opportunity. Some fared rather well, survived Prohibition and continued a legacy in the United States. Many are, sadly, gone forever. The nation's beer history has been relatively short but wildly eventful. We no longer think of beer as simply a straw-colored, low-alcohol, carbonated distraction. The country's breweries are becoming confident and innovative. They are both stepping boldly into the future and reaching back to styles of the past. For the first time in our history, we have a generation of young adults whose first experiences with beer are craft products. Our national audience of beer enthusiasts is among the savviest in history. If you don't count yourself among them, it's OK. This is also one of the friendliest and most approachable industries for hobbyists. This book is about more than the crafting of a delicious and technically

correct brew. It is also about the kind of people, community and culture that must exist to create such special products. This brings me to a place that exemplifies this very spirit: a little place called Fort Collins, Colorado.

Colorado is a beautiful, magical place for a great many types of people. Its visual aesthetic is the inspiration for poems and prose. Colorado's Rocky Mountains provide a wealth of activity, from hiking and biking in the warmer months to snowshoeing and skiing in the winter. The state is known for its active population and has long been a premier place for professional athletes to train. Many have flocked to this state for its liberal views on recreational and medicinal marijuana. But, for our purposes, Colorado is renowned for great beer. According to the state's website, Colorado is home to 230 breweries as of July 2016, which is more than 10 percent of the nation's share. It is safe to say that we are perceived as a beer destination on the national and international stage. So, in a state full of spectacular beer, what make Fort Collins so darn special?

Fort Collins began as a small frontier town facing many of the challenges of other western outposts. Its residents did what they could to bring civility to the Wild West; cutting off alcohol was part of that mission. The city's story mimics the rest of the country, for a time. In 1933, the tale takes a fork in the road. While most of the country repealed Prohibition, Fort Collins was not so hasty. This further shortened the city's available beer timeline yet in no way slowed its progress. By the late 1980s and early 1990s, this college town had several little breweries setting up shop. We know some of them today as pioneers and giants of the craft beer movement. For many people, New Belgium's Fat Tire was the first craft beer they'd ever consumed. New Belgium and Odell have created a dogma that is alive and practiced among most Fort Collins breweries today. In my lifetime, Fort Collins has played a pivotal role in the advancement of craft beer and the enrichment of a beer community. Today, the city has about two dozen craft breweries and has created an environment that promotes sustainability, quality, innovation and a "fraternity" that boasts some impressive numbers of female owners and brewers. It has been my distinct pleasure to meet many of the people who work every day in a popular, yet not particularly glamorous, industry. They all have a common bond: they toil, obsess, risk and empty their savings, all for the love of beer. I will do my best to honor and capture the spirits of the frontier that still exists in these great people.

This book is a timeline of Fort Collins beer, told in stories. Grab a beer. Let's have some wholesome, beer geeky fun.

Part I
A Condensed History

1

The Birth of a Frontier Town

The city of Fort Collins is a lasting monument to the early days of the western frontier. It has a rich legacy of unusual historical figures, political and civic structure and a commitment to maintaining the past while moving into the future.

The first lasting influence in this corner of the great, unknown West came in the early 1800s with the fur-trapping trade. French Canadians trapped in Wyoming and Idaho and had developed an impressive network of camps and temporary settlements along the Green, Snake and Yellowstone Rivers. They were the first white explorers of the Colorado Territory and had documented records by the early part of the nineteenth century. On one particular excursion, a group of trappers became caught in a blustery snowstorm that threatened their travel and their lives. In order to continue their journey unfettered, they buried their heavy gunpowder. This incident led to the name of the river that flows through present-day Fort Collins: Cache la Poudre ("powder's hiding place"). In 1862, the Ninth Kansas Volunteer Calvary established Camp Collins, a settlement for civilian travelers along the Overland Trail. A massive flood of the Cache la Poudre River in 1864 forced the soldiers to move to higher ground in an area near modern-day Old Town. This flood was the first, but certainly not the last, of many in the area.[1]

The settlement became a residence for many people, and permanent structures soon followed. The first liquor establishment was in a two-story building on Jefferson Street in 1875. The second story served as the town meeting hall. The Colorado Railroad built a line through town two years later,

the same year Colorado became the nation's thirty-eighth state, allowing for greater continuity and connection to goods from outlying areas. By 1879, the city had constructed the first building, known later as "Old Main," for the Colorado Agricultural and Mining College. This early precursor of higher education changed its name to Colorado State University in 1957. The city was growing quickly, but it was also carefully constructing a solid foundation that would allow it to prosper many decades into the future.[2]

Not all residents were as committed to the social fabric of this new outpost. Many frontiersmen were nomadic, traveling from town to town for quick money or perhaps away from their troubles in the East. As was common in the nineteenth-century West, unattached men often sought entertainment with their newly earned money in the form of drinks and dames. By 1880, Fort Collins had thirteen saloons and five brothels. These establishments contributed to increasing crime. Violence, theft and arson became prevalent. The city increased liquor license prices from $300 to $1,000 to deter the opening of additional saloons and bars, though it seemed that this did little to quell the delinquency.[3]

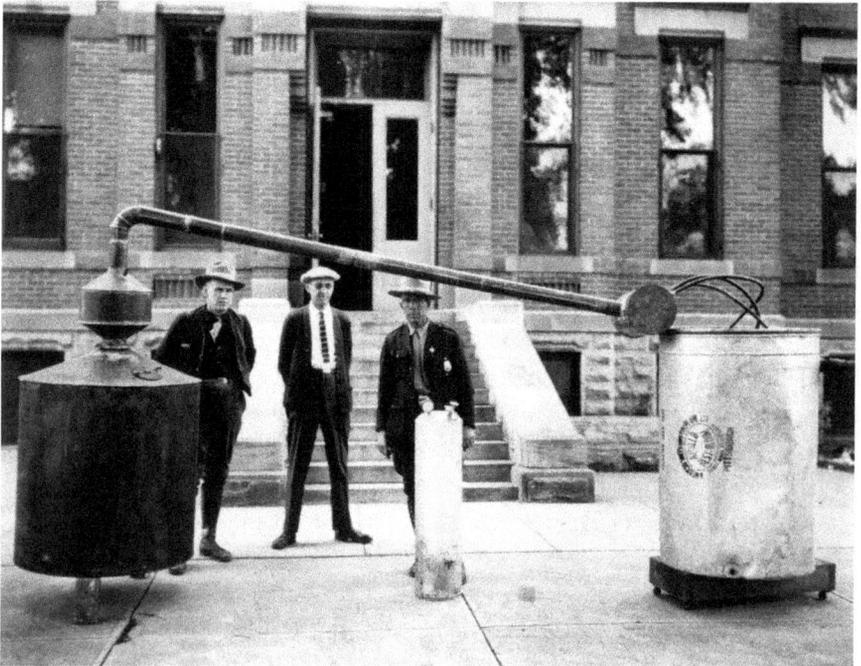

Fort Collins police posing with a confiscated still after Prohibition was enacted. *Fort Collins History Connection.*

After just nine short years of mismanaged public alcohol consumption, the city made its first attempt at prohibition in 1884, banning the sale of alcoholic beverages within the city limits. Those residents who enjoyed their spirits apparently took little heed of this new legislation. The fines for distribution and consumption were considerably less than the previous cost of liquor licenses; the law was repealed when the city realized that is was actually losing money and not accomplishing its goal particularly well.[4]

While the old West has a reputation for being savage and lawless, some civil rights were enacted. The West was far more progressive in terms of women's suffrage than were many states back east. Colorado wasn't the first state in the country to give women total voting rights (it did so in 1893), twenty-seven years before the Nineteenth Amendment was ratified. (Wyoming was the first.) Colorado was, however, the first state to grant this right by public referendum, meaning Colorado men voted in a (small) majority to allow this civil right.[5] One can speculate that the conditions on the frontier were so challenging that women had an opportunity to earn their place in the community in a way that eastern women were not afforded. In any case, women were offered the vote, and in Fort Collins, they quickly took on political positions.

After receiving the vote in 1893, the city's women quickly mobilized to take on the issue of prohibition. The Christian temperance movement had made its way to the area, allowing for greater support of the notion. Many women championed this cause in the wake of the violence and crime that frequently resulted from overindulgence in alcohol. By 1895, Alice Edwards had been elected alderwoman (the first female elected official in Fort Collins) and Frederick K. Bates was elected mayor.[6] Both were proponents of temperance and enacted the city's prohibition the next year, twenty-four years before the Eighteenth Amendment.[7] This time, it stuck. Fort Collins would be barren of legal booze for seventy-three years.

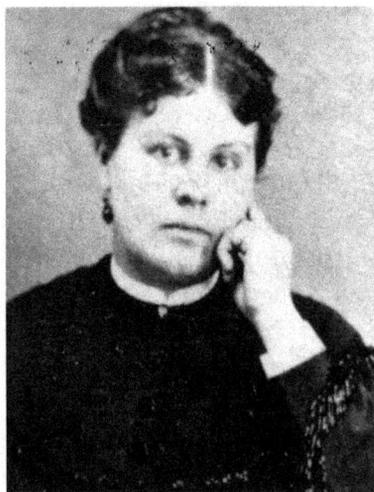

Alice Edwards, Fort Collins's first alderwoman and the city's first woman to hold public office. *Fort Collins History Connection.*

2

The Long Road to Recovery

In January 1919, the nation took Fort Collins's lead and ratified the Eighteenth Amendment, prohibiting the manufacture, sale and transportation of intoxicating beverages. The amendment went into effect one year later. This is often thought of as a dark time in the country's history because it created an opportunity for illegal operations to meet the demands of a previously upstanding, law-abiding group of Americans. As with most illegal substances, prices increased and quality was not monitored by any legal department or authority. An average of one thousand Americans died every year during "the noble experiment," as it became known, due to tainted and toxic bootleg liquor. Fort Collins and the rest of the country was touched by this new criminal element.[8] In fact, Robert Miller, owner of Fort Collins Bottleworks, was a legitimate businessman prior to Prohibition, manufacturing bottles for soft drinks and, most notably, Coors' "golden lager beer." After Prohibition was enacted, Miller continued the business of making soft drink bottles, though local authorities suspected that he was aiding bootleggers. Whether this was true is a matter beyond the evidence available, but he was never arrested or tried for the crime. Instead, he was shot in his store on 175 North College Avenue.[9]

The economy suffered, due to the loss of brewery and distillery jobs, loss of excise taxes and increased money spent on enforcement of the law.[10] The country came to its senses just thirteen years later, passing the Twenty-First Amendment, which created a system for the sale and

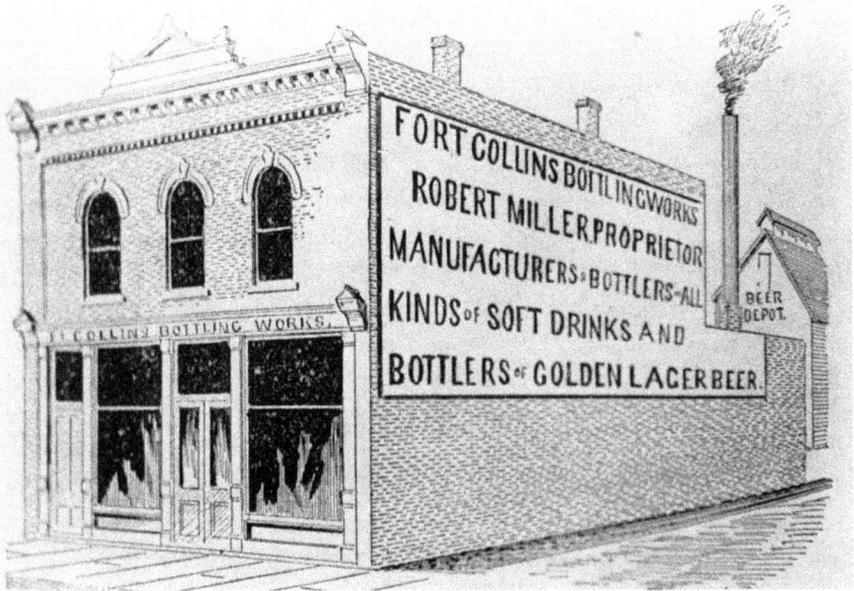

This is an illustration of the Robert Miller Building, erected in 1883. Robert Miller was shot and killed here under suspicion of aiding bootleggers. *Fort Collins History Connection.*

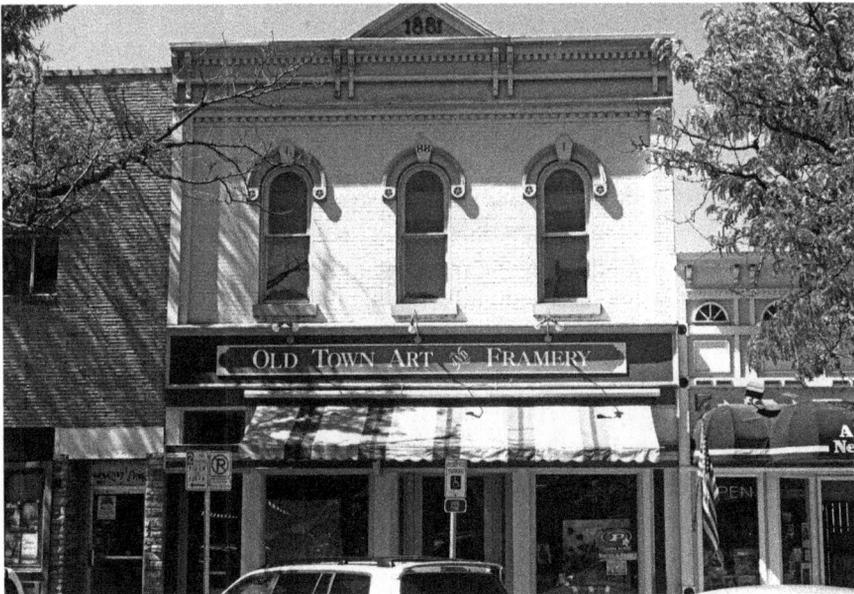

The Robert Miller Building, former home of Fort Collins Bottling Works, as it is today, at 175 North College Avenue. *Gus Hoffman.*

distribution of alcohol that would guarantee Americans the right to be involved in this industry moving forward. As with many federal laws, there are often opportunities for states and municipalities to enact the laws as they see fit. Fort Collins chose to continue its temperance movement until 1969.[11] This isn't to say that drinking was illegal (it never was), but production and sale were prohibited, save 3.2 percent beer, thus creating a huge gap in the city's ability to compete in terms of breweries and distilleries.

By 1969, Fort Collins was late to the party, and it was a particularly dismal time in our nation's beer history. The country had not yet recovered from the loss of so many small and varied breweries that simply could not rebuild after more than a decade of being deemed part of the national curse. By the mid-1970s, there were fewer than one hundred breweries, a nadir for the country since the Declaration of Independence.[12] The products that dominated the market were largely similar in flavor and style, save a few gems, like Anchor Brewing in San Francisco. This was not a time when swimming against the current was particularly in vogue; because of this, at least a generation of Americans thought of beer as monolithic. At this time, there was a beer packaged generically, in a white can with black lettering that read, "Beer." Another dark time was clearly upon us.[13]

The first movement into breweries came when Anheuser-Busch was looking for a location for its twelfth U.S. brewery in order to increase its capacity after a period of significant growth in the late 1970s and early 1980s. After much research, in 1982, the beer giant settled on Fort Collins, in part because of its excellent water source and an impressive amount of local talent. The geographic location also made sense for distribution purposes, ensuring fresh beer with easy access to mountain states and the Pacific Northwest. The brewer saw the additional benefit of increasing distribution in the home state of Coors, its major competitor. Anheuser-Busch broke ground in 1985; by 1988, the first brew and shipment had occurred at the facility.[14] As of 2013, the brewery produced twenty-six different beers, including the recently acquired Goose Island 312, IPA and Honkers Ale. The brewery services twelve states and supplements beer supplies in six others.[15]

Anheuser-Busch has stayed competitive in terms of brewery attractions. It offers two types of guided tours: a complimentary tour of the Budweiser line for the general public and a paid in-depth tour that allows access to cellar facilities and the brew house and provides the opportunity to sample

beers throughout the process. The brewery offers Beer School, a beer appreciation class for those looking to hone their understanding of flavor and terminology. If you just want to sip a brew and relax, there's also a biergarten that offers a beautiful mountain view.

Another early adopter to Fort Collins was the RAM Restaurant Group. In 1974, Jeff Iverson Sr. came to Fort Collins with the idea for what was called a "Deluxe Tavern": a restaurant/bar that offers hot food, an array of draft beer and TVs for sports viewing but that maintained a family-friendly environment.[16] The idea is pretty familiar today, but it wasn't in the mid-1970s. The RAM group had opened its first tavern in Lakewood, Washington, three years earlier. When it set about this expansion, the company knew it wanted a college town. After visiting Fort Collins, Iverson was sold. The new concept was called C.B. & Potts. It has become a Colorado State University student and alumni institution. Now, that's a nice story, but it doesn't mean much contextually until 1996. That is when C.B. & Potts started brewing its own beer. From this point, the tavern became a brewpub, producing some solid, award-winning beers. It also produced some exceptional brewers who have gone on to their own projects, some of whom will be discussed in later chapters. What made working at C.B. & Potts different from any other brewery position? Dave Iverson, son of Jeff and current co-owner of RAM Restaurant Group, remarked that part of their success is hiring great people. In addition, it is a different sort of brewery job because of the brewpub experience. Brewers are often engaging with the public: talking about beers and the brewing process, often working in a literal glass house within the establishment. I suppose having to explain one's job repeatedly to people who may not have the first idea about it would improve a brewer's ability and comprehension. The proof is in the accolades this team has won. In the last twenty years, C.B. & Potts has been awarded forty-six Great American Beer Festival medals and nine World Beer Cup medals.[17]

3

A New Start

The Pioneers of Fort Collins Beer

It's 1988. We have the beginnings of a sports bars and the Anheuser-Busch brewery on the edge of town. Colorado changed the existing law so that manufacturers of beer could sell directly to the public. This was the piece of legislation that made possible the Colorado beer scene possible we know today. Early adopters of this in the state include Wynkoop Brewing Company in Denver and Carver Brewing Company in Durango.

On January 6, 1989, Joseph Neckel got his business license for Old Colorado Brewing Company, the first microbrewery in Fort Collins. Neckel was a certified German brewmaster and came from a family of beer purveyors.[18] The change in legislation was just the push to get him to start his business. The beers had a good deal of German influence, but he did not limit himself to any particular style. A bold man, his first brew was a Rauchbier. For those not well versed in German styles, a Rauchbier is a smoked beer that can vary greatly. It can be an ale or a lager in a variety of styles, but the smoke is what ties the varieties together. It is a style that creates a specific and often polarizing taste. Joseph carried on and continued to keep meticulous journals of all of his recipes. The brewery occupied the space at 172 North College Avenue, which is now the Northern Hotel. Old Colorado Brewing Company's grand opening party took place on October 13, 1989. The brewery stayed small, but it was productive. In 1992, it moved to a different location on Link Lane, where it brewed and opened a restaurant called Casa de Colorado. The brewery/restaurant stayed at that location until Joseph Neckel got out of the business altogether a decade later.[19]

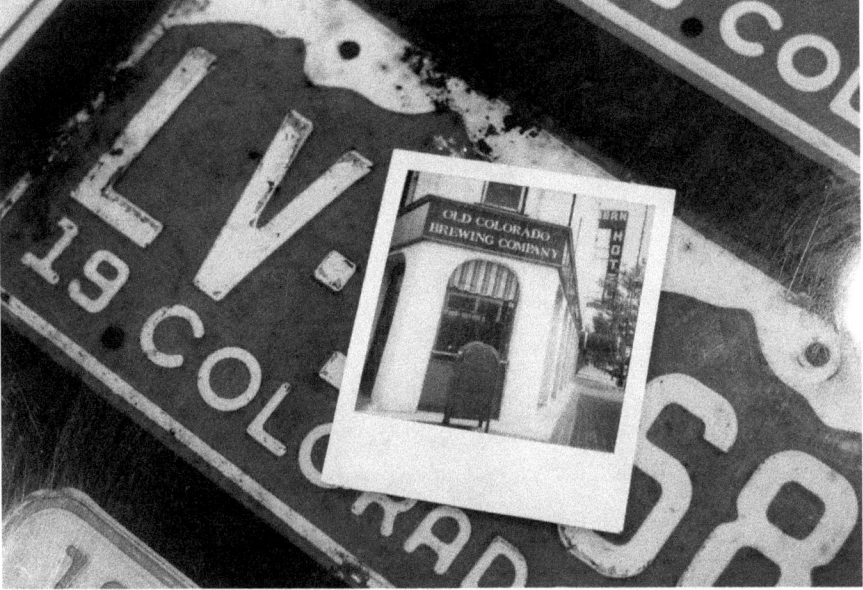

Polaroid photograph of Old Colorado Brewing Company's first location. It was taken at the new taproom at 8121 First Street in Wellington, Colorado. *Gus Hoffman.*

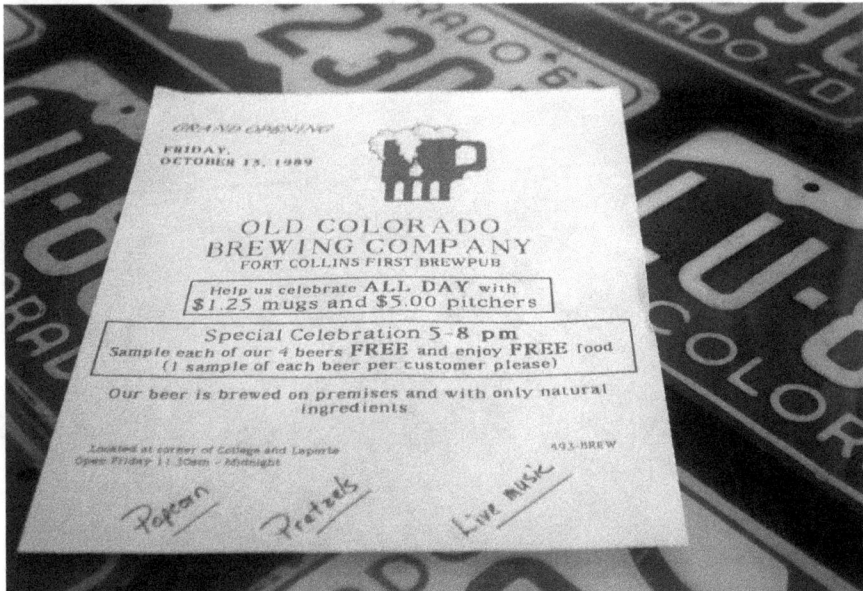

The original flyer advertising the official grand opening party for Old Colorado Brewing Company. *Gus Hoffman.*

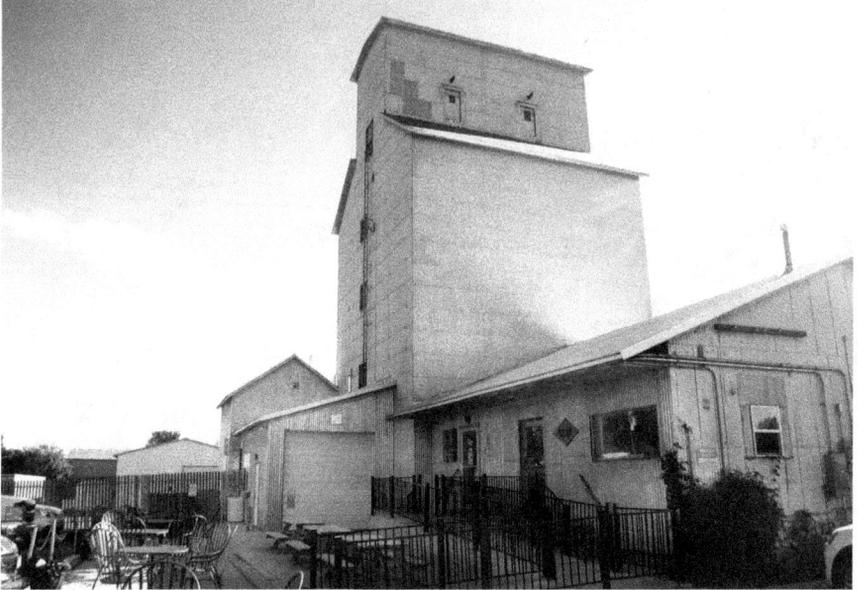

Outside of Old Colorado Brewing Company's facility. This is the outside of the original 1922 grain elevator that the family chose to keep intact. *Gus Hoffman.*

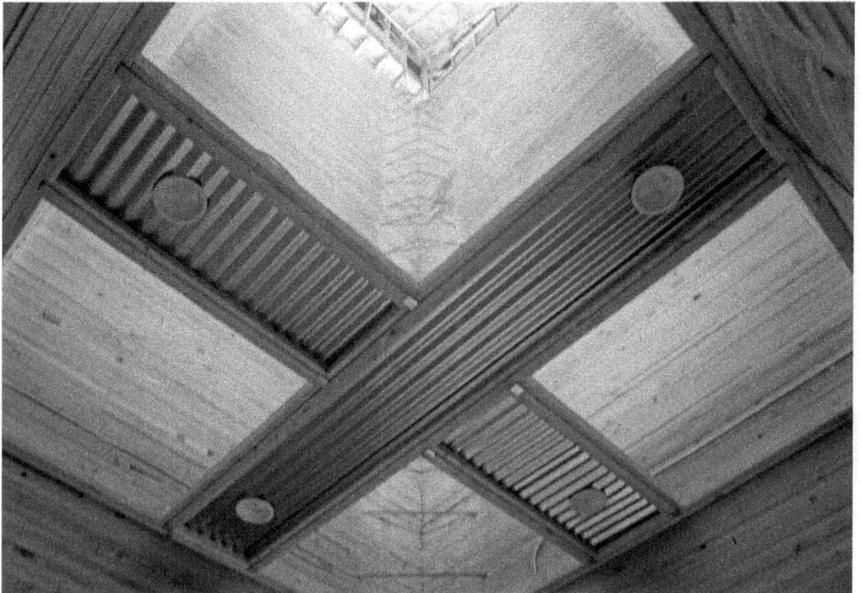

The ceiling in Old Colorado Brewing Company's new location. This is an inside view of the 1922 grain elevator. This design choice was made to honor the history of northern Colorado and the Wellington area. *Gus Hoffman.*

Brandon Neckel, Joseph's grandson, moved to Fort Collins with his family in 1991. He recalls the days of Casa de Colorado with fondness. As he grew to be an adult, Brandon and his wife, Tara, considered reestablishing a brewery using his grandfather's recipes. Joseph is still around, so he gave his blessing to the project. Once they received the endorsement, the couple started looking for locations.[20]

The new brewery is in Wellington, Colorado, about fourteen miles northwest of Fort Collins. An old sugar-beet community, Wellington was established in 1905 as a farming community. The Neckels settled on a 1922 grain elevator to build their brewery. They changed very little about the aesthetic, as this was part of the idea. This brewery serves to honor history in many ways. The current brewery has twelve taps. Usually, half of its selection is made up of the grandfather's recipes and half are new selections. Head brewer Daniel McCue met the couple in 2015, about the time they purchased the location. The Neckels and McCue immediately felt a rapport. They all felt strongly about honoring the past while moving into future innovations. Old Colorado is also honoring the farming tradition by using Colorado ingredients in many of its beers. At the taproom, these local ingredients are indicated on the chalkboard with a Colorado state flag

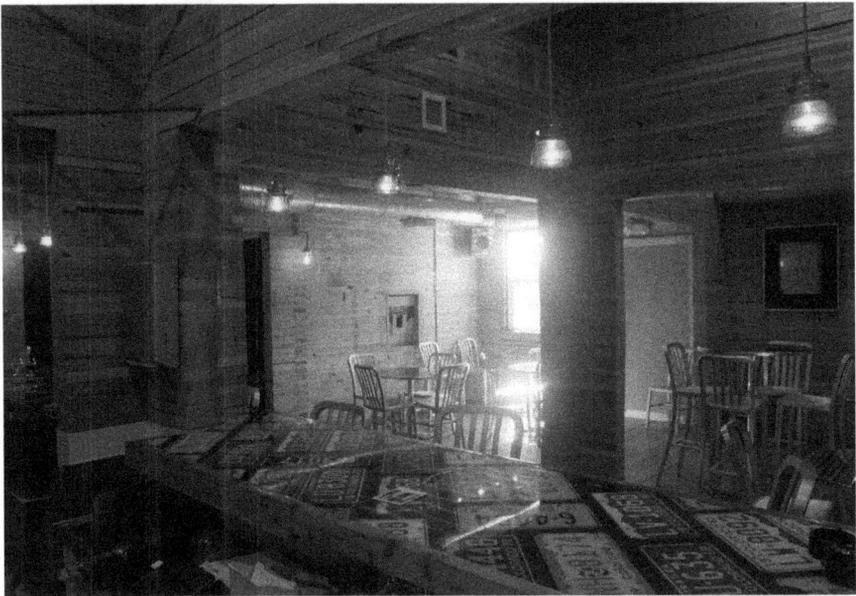

The warm and inviting environment inside the Old Colorado taproom. Here, patrons can choose one of Joseph Neckel's original recipes or something new. *Gus Hoffman.*

icon. The taproom is unique, located inside of a grain elevator. Drinking a pint while surrounded by wood is always a nice feeling. Above, the inner workings of the grain elevator are visible and are certainly a conversation piece. Brandon, a frequent presence, loves nothing more than talking about his family business and the history.

OK, back to the late 1980s.

The laws had just changed. Old Town Square was in foreclosure and being managed by a Chicago insurance company. The people of Fort Collins rarely ventured into downtown because of perceived parking issues and a general lack of familiarity of the old part of town. Scott Smith was working at Old Chicago as a manager.[21] With his love of beer, he had implemented the World Beer Tour, a beer club that encourages patrons to try a variety of beers for prizes and bragging rights. The club was immediately popular. The restaurant was packed every night with folks eager for the variety (110 beers) available. A chef from Denver came in and began talking to Smith about a new brewpub he was opening called Wynkoop. This was the first that Smith had heard of the change in the law. It became clear to him that now was the time to jump into this brewpub idea. With the help of several investors, including Wynkoop Brewing Company,

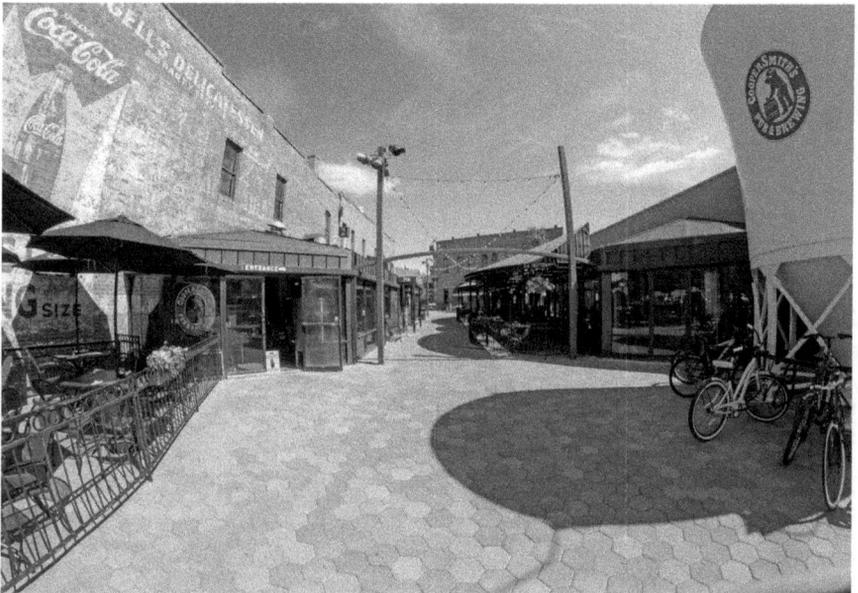

Panorama of CooperSmith's, an entry into Fort Collins's Old Town Square. CooperSmith's became the anchor that put this historical area back on the map. *Gus Hoffman.*

Grain silo in front of Coppersmith's Pub and Brewery. *Gus Hoffman.*

CooperSmith's was born. Named after his son, the new brewpub settled in at 5 Old Town Square. The price was right, due to the fledgling area. The brewpub had its grand opening party in November, and the establishment was a huge success. CooperSmith's is the longest continuously operating brewery in Fort Collins and became a model for how to build and operate such an establishment.[22]

Since 1989, the business has continued to grow, strengthening the brand and the community around it. The restaurant/brewery became an anchor of the square, buoying other businesses and earning the community's trust. Old Town Square, a landmark, is now Fort Collins's signature district. CooperSmith's now occupies three spaces in Old Town Square: the brewery, the pub and "poolside," a billiards room. In 2014, Scott Smith and his wife, Jane Liska, looked toward retirement and sold their shares to the restaurant. CooperSmith's is now majority owned by the three managing partners: Dwight Hall, Sandy Longton and Chris O'Mara. Each person manages a portion of the business. They all started many years ago in entry-level positions.[23]

Some of the first beers brewed in 1989 were Albert Damm Bitter, Poudre Pale Ale, Horsetooth Stout and Pedestrian Ale, an approachable blonde ale. Since then, the brewery has produced 150 recipes and has 15 selections

CooperSmith's pub, brewery and "Poolside" (pool room) early on a summer morning. The brewery and pub occupy three spaces in the square. *Gus Hoffman.*

at any given time.[24] Any beer geek trip to Fort Collins should include this restaurant as a part of the pilgrimage. Its history and the sheer volume and variety of beer alone should clinch a spot on the list.

These establishments were able to open their doors before the competition, but the competition wasn't far behind.

Part II
Craft Trailblazers

Odell Brewing Company

The "British" Invasion

The story of Odell Brewing begins in the mid-1970s, far from our sleepy little city in northern Colorado. Doug Odell started home-brewing with a buddy after college. By 1978, he was going to school in San Francisco and got a job working for Anchor Brewing Company, one of the first craft breweries in the country and certainly one of the few that survived federal Prohibition. He worked not as a brewer, but more as an assistant, cleaning tanks and such. Doug speaks of his time at Anchor with fondness, but he decided to finish his degree in Sonoma County, forcing him to leave his post. After graduating, he moved to Seattle. He applied to Red Hook Brewing Company many times and had his hopes dashed with each attempt. He speaks of this time as a blessing in disguise.[25] After all, had Red Hook hired him, the story may have ended there. He met Wynne around this time. They married in 1986 and took their honeymoon in the United Kingdom, where passion met inspiration. The beer styles produced in England, Scotland and Ireland were a far cry from the Rainier Ale they drank in Washington State. These styles would inspire the brews that Doug Odell perfected as a hobbyist and would become the foundation for Odell Brewing Company.

The Odells were a young, newly married couple trying to construct a plan and careers that they enjoyed. Doug was running a landscaping business alone, and Wynne worked in banking. On their return from their honeymoon, they were filled with inspiration. They decide to try to start a business at which they could work together. They had begun their relationship by checking out the new breweries in Seattle and shared a passion for beer. The Seattle beer scene was already established to a certain extent, which made them think

Drinking beer can lead to confusion. Odell Brewing Company has thought of everything! *Gus Hoffman.*

Odell's iconic hop flower logo outside the taproom. *Gus Hoffman.*

that the market was already saturated. (Can you imagine?!) The next step was finding a city to call home: it needed to have accessible land, possibly an existing structure for the business, and young, hip drinkers who might embrace something new. Doug's sister Corkie was living in Fort Collins at the time. The small college town fit the bill and proved to be a perfect location for the Odells' plan. And with the Colorado brewpub law of 1989, the timing could not have been better. They bought a 1915 grain elevator to house the new brewery in May 1989.[26] These kids had stumbled on the perfect storm of location and timing in craft brewing history, but their story isn't without setbacks and struggle. In the beginning, Wynne took a job with Hewlett-Packard and, in her off time, ran the accounting and licensing aspects of the new brewery, while Doug brewed, bottled, sold and distributed on his own. They worked tirelessly to get to their grand opening celebration at Old Chicago, which followed a friendly "race to the starting line" with another new brewery, CooperSmith's, which opened two weeks prior. CooperSmith's opening was very successful and packed with locals, eager to sample the new local beer. Odell's party was not. Doug Odell recalls of their party and their high hopes:

> *That got dashed a little bit on opening night....I went to their [CooperSmith's] opening and it was just, totally, jam packed. People waiting to get in and I'm [thinking] "Oh, my goodness, wow, this is great." Then we had our opening two weeks later at Old Chicago and, it was, very dismal, they really didn't sell anymore than they normally did on a regular night, like a Wednesday or Thursday night or whatever day it was. We brought over, like, three kegs and we went through half of one the whole night, maybe a quarter. My sister, Corkie and Wynne set up a stand to sell some t-shirts and they sold, like, three or something. And we're thinking, "Oh my goodness, what have we done?"...I was concerned, but it wasn't going to stop me.*[27]

It is an all-too-familiar story to anyone who has started a small business, played in a band, opened a restaurant or otherwise made the leap to share a very personal passion with their community. That sort of sick feeling of planning a party that nobody attends and the resulting combination of crushed ego and wallet. But failure was not a feeling this fledgling businessman would experience for long. Within four to six months, the young brewery was already seeing the beginnings of a fan base.

Golden Ale was one of the brewery's first releases in 1989.[28] It was a very approachable, well-balanced ale. It is no longer in production, but Odell Brewing loves to revisit old recipes every so often. In fact, it re-brewed Golden Ale specifically for the Moot House's twenty-fifth anniversary party in 2013. Moot House was one of the brewery's first supporters, carrying

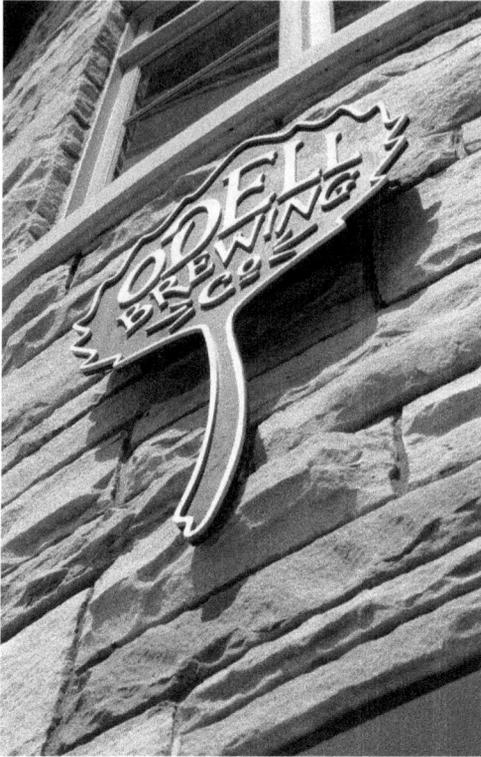

Odell's hop flower logo is seen in this photograph, taken from the doorway. *Gus Hoffman.*

Golden Ale on draft. Another of the brewery's early works is 90 Schilling, a wee heavy/ Scotch ale whose name is a callback to the origins of the style in Scotland. Scotch ales came in different strengths at the time, and the cost was directly related to the strength. They came in sixty-, seventy- and eighty-schilling varieties. This beer has become Odell's flagship ale. It is a beautiful coppery red, malt-driven with a mouth feel that is substantial without being overwhelming. As time passed, the Colorado beer audience became more sophisticated, and the selections continued to expand. Odell has ventured into many beer categories, far beyond its British roots. In recent years, the brewery has expanded to create beers ranging from Lugene, a sweet stout with milk chocolate, to Brombeere Gose, a blackberry-infused gose, which is a traditionally German style wheat beer that tends to be slightly tart, herbal and salty.

Many of these beers are brewed with a purpose beyond just creating a particular flavor profile. Lugene, the aforementioned sweet stout made with milk sugar and milk chocolate, was named after the farmer who has been feeding his cattle with Odell's spent grain for over a decade.

Limited edition Odell bottles and seasonal line artwork adorn the wall in the Odell taproom. *Gus Hoffman.*

Lugene and his old farm truck can be found at the brewery from time to time—a kind of Odell "celebrity sighting" if one is lucky to spot him. Celastrina Saison, Odell's first saison, was named for *Celastrina humulus*, a rare blue-and-purple butterfly that is found flying around wild hops in the Front Range of Colorado. Part of the proceeds were donated to the Colorado National Heritage Program, which maintains the state's only comprehensive database of rare and endangered flora and fauna.[29]

The brewery is, at its core, about loyalty and novelty. The new facility, built in 1994, includes a pilot brewing system. It brews five barrels at a time and is the starting place for all of Odell's new ideas. Most new mass-produced Odell varieties start as a pilot beer. Have a great idea for a beer? Hail from Maryland and want a beer with Old Bay in it? If you are an Odell employee, you need only sign up; the brewers will help you create your masterpiece. These beers are sold in the taproom alongside Odell's classic creations and pet projects. Other than being perhaps the greatest employee benefit of all time, it allows Odell myriad opportunities to produce new and exciting beers. It also encourages all employees, regardless of their position, to become educated and involved in the brewing process. These beers are then sold in the taproom, with varied results. Any beer that does well has the chance of becoming a large-batch beer. That Old Bay beer did rather well in the taproom and was poured on draft at a couple of local restaurants (yes, it was real). Feelin' Crabby, a 6.2 percent ABV (alcohol by volume) pale ale with Old Bay seasoning added to it, was the brainchild of Sam Gaver, one of the 120 employee-owners thinking in their own way.[30]

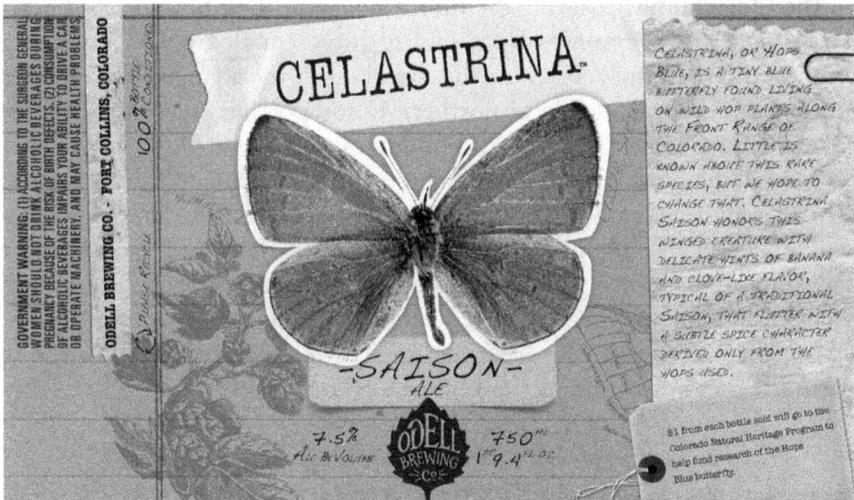

Original label for Celestrina Saison. *Odell Brewing Company*.

The mash tun room at Odell, paired with Drumroll APA and sunlight. *Gus Hoffman.*

In 2015, Doug, Wynne and Corkie Odell converted the company's stock into an ESOP (employee stock ownership plan). This plan allows every employee to own a stake in the company. After much discussion, the original owners made this decision because of their commitment to maintaining the culture of this brewery. This was also an exit strategy for the Odell family, ensuring the future legacy of their brainchild. These days, many craft breweries have sold to large conglomerates and have been paid handsomely. It seems this simply isn't the style of Fort Collins breweries. Three out of four of northern Colorado's largest craft breweries have opted for some ESOP at this point in history. Doug Odell said of the decision in the press release, "While these options [selling to private equity firms] are more lucrative than the one we chose, we believe that the people who built OBC are the best ones to lead us successfully into the future."[31] The employees are rising to the occasion, but for many of them, this hasn't changed how they feel about their work and the culture. It is nonetheless a huge point of pride. Marni Wahlquist, Odell's cellarist, had this to say about the announcement of the ESOP:

> *It was very emotional, and it just is so consistent with what we're already doing and, I feel like how we're already running it…a lot of the things that we were doing pre-ESOP is having the* [employee-run] *committees and constantly nurturing our Odell culture for all of us co-owners was already*

in place....It's so wonderful that we're staying independent and we also have even more pride in our brewery because it is ours.[32]

Marni started at Odell after a career in fermented foods and kombucha. She started at Odell in packaging but was later tapped for the cellarist position, which largely deals with yeast culture maintenance, because of her experience in fermentation and her heightened interest in the brewing division. This is another aspect that speaks to Odell's ability to not only appreciate its employees' talents but also utilize them to the advantage of the company. Odell has several employee-manned committees that handle pertinent issues. The wellness committee supports healthy lifestyle choices, offers nutritious snacks and plans hikes for exercise and team building. The culture committee has as its primary objective to maintain the connection among employees outside of the work environment and to cultivate the Odell culture.[33]

Odell has created a culture of sustainability and conservancy that, along with other Fort Collins pioneers, has set a standard for the newer members of the brewing industry. Odell uses just shy of four gallons of water for every gallon of beer produced; the national average is more than seven gallons. Water for rinsing and cooling is reused, and a modification added to the vacuum pump in 2012 allowed the brewery to save 2.5 million gallons the first year.[34] Most of us may not think of water conservation as a hot-button

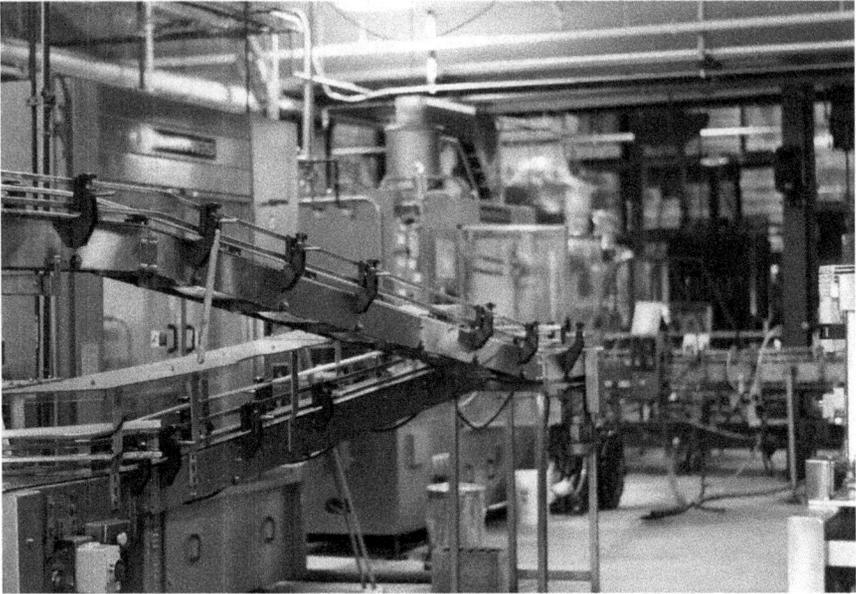

Odell's packaging line. *Gus Hoffman.*

environment issue, especially with climate change and genetically modified food taking up so much of the spotlight. But when it comes to beer, water is essential. It is ideal to brew with a pristine water supply, which explains why breweries tend to congregate in particular regions. After all, like us, beer is mostly water (beer wins at 90 to 95 percent). The water for Fort Collins comes from the Cache La Poudre River. It is worth noting that there is no major usage upstream from the city, and with no usage, there is also no pollution. The brewing industry understands this gift, and Fort Collins brewers spend a great deal of effort protecting it.

Odell also uses clean energy to power its facility, in the form of solar panels and wind energy. The facility uses insulated brewing vessels and recaptures steam from the boil to help heat the next one. The warehouse has special sunlight sensors that automatically dim the LED lighting when the sun is bright enough to light the building. The company has a goal to be "zero landfill" by 2020; as of 2016, it has attained an impressive 87 percent of this goal.[35] The employee-run sustainability committee is spearheaded by Cory Odell, daughter of Wynne and Doug. She has been enthusiastic about implementing conservancy measures, from the employee level to the brewing level. The company's forward thinking looks to the future, as well. The brewery is currently working with the City of Fort Collins to see if spent

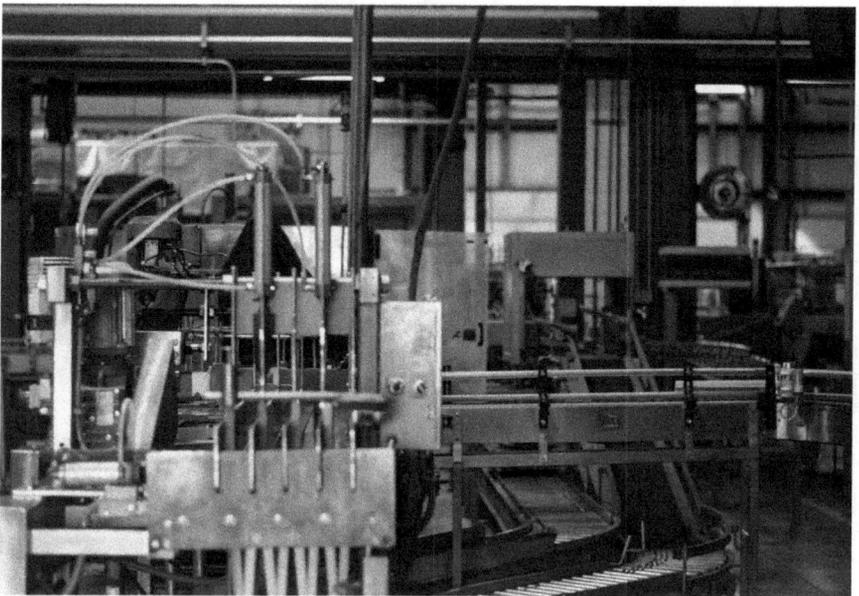

Odell's bottling line was acquired from Flying Dog Brewery when the company moved from Denver to Maryland. *Gus Hoffman.*

yeast can be reused as a chemical-free method of water treatment. Odell is also trying to develop a way to use water that is non-potable but unpolluted in irrigation.

In recent years, the brewing team at Odell has continued to push itself for new and exciting ideas. The barrel-aging program has expanded into a full-scale project of its own. The brewery has expanded into wild ales, casually known as "sours," though not all of them are particularly tart. Most notable in 2016 was Prop Culture, a limited-edition, bottle-conditioned ale using more than ten Belgian yeast strains that Odell propagated in different combinations (hence the beer's name). Saccharomyces and brettanomyces were added in different stages for structure and funk. The idea was inspired by Brendan McGivney's recent trip to Belgium and was rare in that it did not begin in the pilot system.[36] This "experiment" was brewed in a one-hundred-barrel batch. While small by Odell's standard, the brew was a bold move. If you are lucky enough to get a hold of a couple bottles (it was released in the spring of 2016, so supplies are very limited at this point), it's fun to try one now and cellar another to see what evolves in this living beer. The yeast will continue its transition due to the bottle conditioning. The young iteration currently has a nose of clove and banana, thanks to that beautiful Belgian yeast. The flavor is delightfully funky but not tart in any way. It develops into tropical flavors, like papaya and mango, with just a touch of floral on the finish.

The most recent limited-edition release (as of October 2016) is Jolly Russian, timed to 2016's Great American Beer Festival, the largest American beer festival in the country, held in Denver, Colorado. This Imperial Russian Stout, aged in rum barrels, is a beast at 13.3 percent ABV, so one bottle will likely suffice. With cacao nibs and rum on the nose, Jolly Russian's silky mouth feel is rich and substantial. The flavor possesses coffee, vanilla and rum. It is charmingly boozy, the kind of beer that was made to be drunk in cool weather, or when it's time to unwind. This beer will stand the test of time if you choose to cellar it, but most brewers recommend sampling the beer while it is still young, if for no other reason than to get a sense of its development. Not into cellaring? Not a problem. Breweries are not in the habit of releasing beers that are not ready for consumption. Cellaring is a fun way to see how wild beers or high-alcohol beers change and develop over time. It is also a fun way to stash a surprise for your future self on a day that warrants something special.

Odell is now twenty-seven years old, with growing pains behind it and truly comfortable in its own skin. It has established practices, enjoys a tremendously loyal following and is striding confidently into a future that it defines for itself. (If only we all felt that way at twenty-seven.)

5

New Belgium

The Bike Ride That Changed America

This story also begins far from the city where New Belgium was founded. In 1988, Jeff Lebesch, a home-brewer and electrical engineer, was biking through Belgium. He happened upon this opportunity when his company sent him to Germany for a job. He shipped his mountain bike to Europe and decided to take a scenic ride through Belgium. His fascination with Belgium and its beer had a lot to do with his interest in the writings of Michael Jackson (no, not the pop star). Jackson, an English writer, is largely credited with creating a renewed interest in beer in the 1970s. He wrote eight books on the topic and had a television series, *The Beer Hunter*. Jackson was fond of discussing Belgian beer in particular and recommended 't Brugs Beertje, a renowned beer café, to those who had the opportunity to visit Bruges. Lebesch arrived in Bruges on a Wednesday, eager to sample delicious beers (of which the establishment had about three hundred selections), only to discover they were closed on Wednesdays, which was not a detail included in Jackson's book. His disappointment made it difficult to surrender immediately, so he sulked a bit, looked in windows and tried to come to some kind of acceptance. As he started to ride away, the owner came out and asked if he could help. Jeff told the proprietor that he was a home-brewer from the United States and that Michael Jackson had sent him. It got him in the door.[37] Jeff helped the owner with inventory and cleaning in exchange for free beer. Sadly, with the passing of Jackson in 2007 and the popularity of this story, this ploy will likely never work again.

This is the original brewing system that Jeff Lebesch and Kim Jordan used in their basement to start New Belgium. It is displayed at the brewery's Fort Collins location. *Gus Hoffman.*

The plaque commemorating the construction of New Belgium's first one-hundred-barrel brewing system in 1995. *Gus Hoffman.*

Lebesch returned to the States with a renewed interest in brewing, particular those styles that he'd enjoyed so thoroughly during his travels. He convinced his partner, Kim Jordan, to have a small brewing operation in their basement that Jeff designed. The first beer brewed in that basement was a Belgian-style dubbel that they called Abbey, in honor of the Belgian monks who created this style. The next brew was based on an amber-hued Belgian pale ale called De Koninck. They decided to call their version Fat Tire, a call back to the nomenclature given to Jeff's mountain bike while traveling in Europe. It quickly became feasible to start a commercial venture in 1991. They brewed in their basement until they rented an old train depot for the first official location, at 350 Linden Street, not far from the current brewery. By 1995, they had already outgrown the first site. Jeff and Kim purchased fifty acres of land in a former sugar-beet processing area to build the new one-hundred-barrel brewing system and taproom.[38] While they have certainly expanded over the years, including the addition of the two-hundred-barrel system in 2002, this is where New Belgium lives today. Kim Jordan, a social worker by trade, became the company's first bottler, sales representative and marketing guru and would become the CEO, a title she held until 2015, when Christine Perich succeeded her. Perich decided to leave New Belgium after sixteen years of employ at the end of 2016. During the transition, Jordan has taken the helm again.

Kim Jordan's social work background factored into the new business in many important ways. The first socially conscious idea they implemented was the decision to donate one dollar from every barrel brewed to charity. That first year yielded approximately enough money to sponsor a child overseas for a month. To date, New Belgium has donated over $8 million to charitable causes in forty states.[39] When the couple first set out on this undertaking, they had a "company retreat" (for the only two employees) to Estes Park, where they created a mission statement of gratitude. That set the stage for their ten core values:

1. *Remembering that we are incredibly lucky to create something fine that enhances people's lives while surpassing our beer drinkers' expectations.*
2. *Producing world-class beers.*
3. *Promoting beer culture and the responsible enjoyment of beer.*
4. *Kindling social, environmental and cultural change as a business role model of sustainable business.*
5. *Environmental stewardship: Honoring nature at every turn of the business.*

6. Cultivating potential through learning, high-involvement culture and the pursuit of opportunities.

7. Balancing the myriad needs of the company, our co-workers and our families.

8. Trusting each other and committing to authentic relationships and communications.

9. Continuous, innovative quality and efficiency improvements.

10. Have fun.[40]

The reason it is important to list these core values in their entirety is to understand the reason this company has been so wildly successful and a model of excellent business practice, particularly for the Fort Collins brewing industry. We live in a culture that routinely accepts business practices that are disingenuous and, sometimes, plain harmful to groups of people, all in pursuit of the bottom line. We accept it because we are told that the function of a business is to make money at all costs, that business can't be expected to care *and* be profitable. New Belgium proves this theory wrong; it is conscientious, innovative, profitable and the fourth-largest craft brewery in the country. The brewery has been a certified B Corp since 2013. B Corp certification is a rigorous process in which companies are vetted for

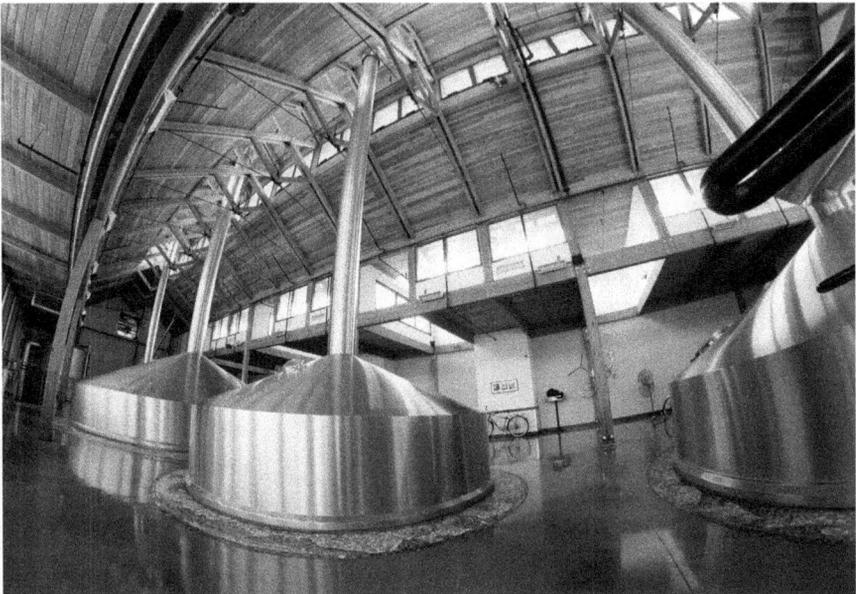

New Belgium's mash tun room. Most of this is part of the 2002 expansion. *Gus Hoffman.*

their social and environmental policies, accountability and transparency. It is a collective of 1,897 businesses from fifty countries that have made a commitment to be the change they want to see in business.[41]

This responsibility to community truly starts within the company. The founders always intended the brewery to be employee owned. New Belgium adopted the ESOP early, with the employees owning 40 percent of the brewery until five years ago. Kim Jordan, planning her eventual retirement, opted to sell her shares to the employees. Again, this follows seamlessly with a career's worth of socially conscious decisions. While the purchase is a long-term process, this ensures that New Belgium is 100 percent employee owned. Employee owners are given shares based on tenure and, if they choose to leave, they sell their share back to the company. After one year of employment, each employee becomes an employee-owner in an annual ceremony and receives a limited-edition New Belgium cruiser.[42] Each year, a new model is introduced. The variations (based on the anniversary dates) are visible along the employee bike racks should you take a stroll through the campus. The gift of a bike is both symbolic and practical. New Belgium has invested a great deal of money and time on bike-path creation and maintenance, shower facilities and covered bike parking on campus to encourage employee health and to lessen the carbon footprint associated with motorized commuting. According to some of its employees, one of the best benefits is the annual company retreat. Every employee, nationwide, convenes for a weeklong reunion in August. There is, of course, education and strategy meetings, but unlike a lot of our jobs, there's great food, fun activities and lots of delicious beer, too. This is also when the employee ownership ceremony takes place.

Sustainability and conservancy can be achieved in many ways. New Belgium's approach is multi-tiered, a result of Jeff and Kim's commitment from the beginning to efficiency and efficacy. Clean energy is a popular issue these days; naturally, New Belgium agrees. The company was 100 percent wind powered in the early 2000s, but it made a decision to switch to solar. While it does purchase some of its electricity from the grid, it "charges" itself for any grid energy used. That money is set aside for projects to make the facility more independent in the future.[43] For example, in 2015, part of the money was allocated to upgrading the insulation and lighting in on-site beer coolers. The upgrade made the company 50 percent more efficient and paid for itself within one year.

Waste management is an essential aspect of conservancy as well. Brewers have a great opportunity to avoid landfill waste in spent grain. Spent grain is

A vintage cruiser bicycle on display at New Belgium. While the company does commission bicycles specifically for its employees, this one is more symbolic. *Gus Hoffman*.

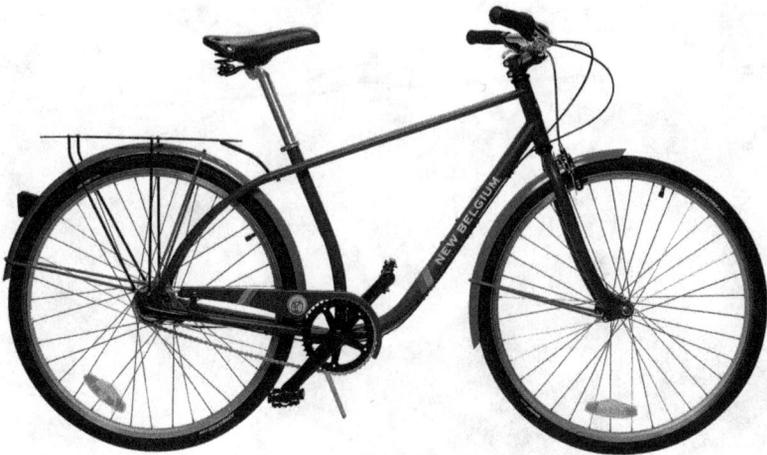

Every year, New Belgium commissions a new design for its cruisers; this is the 2016 model. *New Belgium Brewing*.

An exterior shot of the New Belgium campus. The brewery provides employees and guests many places to park their bicycles to encourage this carbon-neutral form of transportation and exercise. *Gus Hoffman.*

This moving metal sculpture on New Belgium's campus is a working example of the company's use of solar power. As the sun powers the sculpture, it moves, offering facts about the brewery's sustainable-energy practices. *Gus Hoffman.*

There is no shortage of grain storage on New Belgium's campus. *Gus Hoffman.*

the leftover malts and adjuncts after the mash has extracted the useful sugar, nutrients and protein. This accounts for a staggering majority of waste output, in New Belgium's case, 98 percent of its total refuse. The good news is that there are many uses for this byproduct, and breweries get more creative all the time. Spent grain is excellent feed for chickens and cattle; many Fort Collins breweries, including New Belgium, donate their spent grain to local farms. OK, so 98 percent of New Belgium's total waste is gone, no longer an issue. The remainder is where it really excels. Of the 2 percent that remains, 90 percent is recycled and 1 percent is composted. The remainder, which ends up in the landfill, works out to be .18 percent of the original material. This exercise is a little geeky, using a lot of numbers (this will not continue). It makes an impressive point.[44]

Water is a continuing theme throughout our stories because it is the foundation of beer and is, in large part, what makes Fort Collins such an attractive brewing location. It is also a finite resource in a small region that welcomes an ever-increasing amount of new and expanding breweries. Protecting this gem is a top priority. New Belgium uses just under four barrels of water to produce every barrel of beer, according to its 2015 sustainability report. It also has an on-site water treatment facility where it mitigates yeast and other post-brew particulate out of the wastewater via aerobic

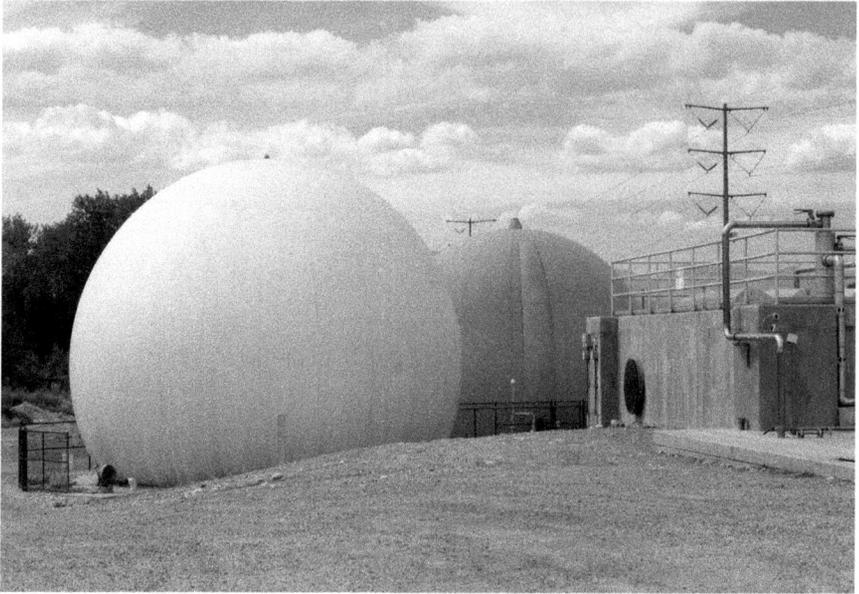

New Belgium's methane "bubbles." This is a phase of the water-treatment process. Methane is stored and later used for heat and energy. *Gus Hoffman.*

and anaerobic processes and then pipes the water directly to Fort Collins municipal water treatment facility. Part of this process creates a chemical reaction that releases methane gas, which is collected in these large white spheres the company refers to as "bubbles," later used as a heat and energy source for the brewery.[45]

As mentioned before, the company was founded with the idea of social and community responsibility. Over the years, New Belgium's home has remained Fort Collins, but its community has expanded to forty states. Remember the program of donating one dollar from every barrel to charity? That money is dispersed through grant requests in every state that sells New Belgium products. The main areas of charitable giving are sustainable agriculture, responsible transportation and water conservation and restoration.[46] The brewery also sponsors youth environmental education, working to ensure a more mindful future.

To supplement this donation program, New Belgium plans many annual charity events. At these events, all proceeds from beer sales go to nonprofit organizations. The most well known is likely Tour de Fat, a touring-bike-centric, costume-filled, beer-drinking summer hullabaloo. This will be discussed later in the book. The Clips Beer and Film Tour began in 2010. It

Canning line in motion at New Belgium. *Gus Hoffman.*

New Belgium processes bottles and cans in its facility. The relative sustainability of cans versus bottles is an issue that the company has not been decisive about yet. Both products have pros and cons. *Gus Hoffman.*

Canning line helix at New Belgium. *Gus Hoffman.*

The name plaque on Foeder number 027 in New Belgium's legendary barrel room, one of the largest beer-aging facilities in the world. *Gus Hoffman.*

Nameplate on a New Belgium barrel from Seguin Moreau Cooperage, a modern merger of two world-renowned cooperages dating to the nineteenth century. *Gus Hoffman.*

travels to sixteen cities nationwide every year and hosts a free event with short films and small-batch beers. The event gives filmmakers an audience and provides a fun, free event to the community. The community in turn gives money to charity with every beer purchased. If you're not much for cinema, perhaps a more active pursuit sounds appealing. Mountain Adventure visits about seven ski resorts in the winter/early spring for a day of snow sports and a scavenger hunt, of sorts. Teams of four compete for fabulous prizes while wearing costumes (New Belgium Brewery really likes costumes). This one has an entry fee of ten dollars per person plus the cost a lift ticket, but there are prizes, and it's all for charity. If you are a little closer to Fort

Giant foeders in New Belgium's barrel room. The company boasts the second-largest beer barrel-aging room in the world. *Gus Hoffman.*

Collins, summer brings the Bike-In Cinema to the lawn of the New Belgium campus. It's like a drive-in movie, but more ecologically responsible. A free movie, delicious beer for charity and five hundred of Fort Collins's finest visitors and residents. What's not to love?

Speaking of love, now seems a good place to discuss what is at the heart of people's love for New Belgium: it's all about the beer. By 1996, the brewery was producing five beers: Abbey, Fat Tire, Trippel, Sunshine Wheat and Old Cherry. Old Cherry, an ale brewed with cherry juice, is the only one of the five no longer in production. Also in 1996, Peter Bouckaert, the current brewmaster, began working with the brewery. They were starting to create seasonal options and wanted the second to be a sour beer. In 1996, people hadn't heard of sour beer unless they'd traveled to Belgium. It wasn't a category in this country. So, they attempted this project. It didn't go particularly well at first. Because breweries in the United States do not make beer with wild yeasts like *lactobacillus* and *pediococcus*, they couldn't just order what they needed. What they did instead was collect wild yeast from any source possible—trips to Belgium, brewer friends, etc. Once they had acquired enough critters, they attempted another sour. It worked. La Folie, French for "the folly" and aptly named, was born in 1997.[47] This dark sour was submitted to the Great

Used small-batch whiskey barrel repurposed at New Belgium. *Gus Hoffman.*

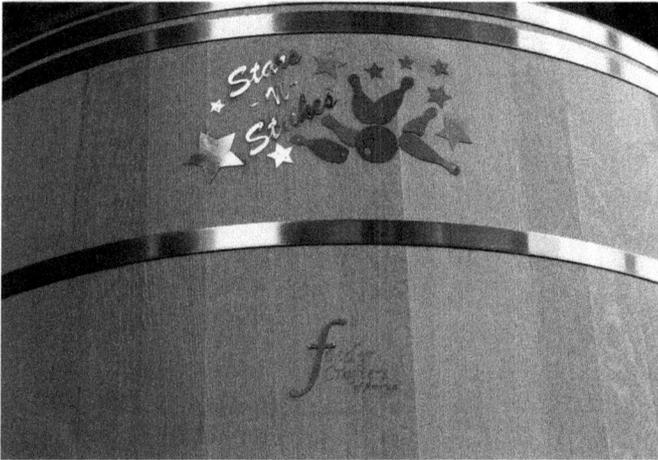

The "Stars 'n' Strikes" foeder was won on a bowling match bet! *Gus Hoffman.*

American Beer Festival for judging that year. There wasn't even a category for it at the time. In contrast, in 2016, there were five separate sour categories at GABF. The brewers have created a La Folie every year since, and the beer continues to develop greater complexity and richness. Part of the reason the company's sour program grows and develops is that first collection of yeasts. That serves as a base for every wild beer they create, in the way that a baker keeps a portion of every sourdough batch as a starter for the next one. New Belgium has two "starters," Felix and Oscar. Oscar, the dark lager yeast sour, is only used for La Folie. Felix, the golden lager yeast sour, is used for all other projects. They live in two of the first sixty-hectoliter foeders the company acquired.[48] Each time a new foeder comes to the barrel room, it is inoculated with one of these wild yeast starters. Working with wood aging

"Stars 'n' Strikes" foeder pictured in its entirety for scale. *Gus Hoffman*.

is a very different pursuit than traditional stainless-steel brewing. Brewing beer in stainless steel is about precision, attention to detail and meticulous cleanliness. A few stray microorganisms can ruin an entire batch of beer. This is heartbreaking and expensive. On the other hand, wood aging involves actually releasing these microorganisms into the beer on purpose. There is a method to it, but it is not precise. Precision comes later by blending batches together to achieve the desired characteristics. Because these processes are so different, they must be kept completely separate from each other, or else there is a very high chance of cross contamination. New Belgium now has the second-largest beer barrel program in the world. Obviously, this came from twenty years of collecting barrels and foeders, each with its own story. One such story concerns Foeder 65, lovingly constructed by the folks at Foeder Crafters of America in Lebanon, Missouri. Ted Peterson, a brewer in New Belgium's wood cellar program, was in Lebanon working on obtaining a new foeder. He and the employees went out bowling that night. Ted has many talents, and bowling is not among them. The Foeder Crafters team was very amused by this and told him if he could get a strike, they would give New Belgium a foeder for free. Apparently, this was all the motivation Peterson needed. Foeder 65, also known as "Stars and Strikes," was provided gratis.[49]

As New Belgium is a great proponent of bringing wild beers to the U.S. market and palate, it has garnered attention from some very famous Belgian brewhouses. Transatlantique Kriek, a cherry lambic, is a collaborative beer with Oud Beersel, a

Barrels sourced from many different locations and circumstances make up New Belgium's barrel-aging project. *Gus Hoffman.*

130-year-old Belgian brewery that specializes in wild ales (often referred to as "sours" in the States). The collaboration began in 2003 and happens annually. The entire process takes eleven months, and the beer travels 7,762 kilometers (4,823 miles). In early January, Oud Beersel begins a wood-aged lambic, which is spontaneously fermented sour ale. By August, Oud Beersel adds cherries to the lambic to make it a kriek, or cherry lambic. After a month of aging, the beer is ready to send to the States by boat. Meanwhile, New Belgium's brewers are hard at work creating their plan for the beer. In early September, they select which Felix foeder to use and start brewing a golden strong lager to combine with Oud Beersel's ale. By late October, all of the components are ready and at New Belgium. This is when the wood cellar team goes about the process of blending these three components. While the team has the final say and there can certainly be some variation year to year, the blend is about 50 percent kriek, 25 percent Felix Sour and 25 percent golden lager. Transatlantique Kriek is ready to be bottled by November, but it is not released until the following February, along with the new La Folie, at the Lost in the Woods party in Fort Collins and at other locations throughout the country.[50]

New Belgium recently collaborated with other Belgian heavyweights like Hof ten Dormaal and Dekoninck, but it doesn't just play on the other

Left: A tall, frothy globe of La Terrior, part of New Belgium's Lips of Faith series. *New Belgium Brewing Company.*

Right: New Belgium's 1554, a schwartzbier, also known as a black lager. *New Belgium Brewing Company.*

side of the pond. New Belgium has worked with many American breweries over the years. Most recently, it took on a very interesting collaboration project for its twenty-fifth anniversary, asking five breweries, Allagash, Avery, Hopworks, Firestone Walker and Rhinegeist, to create their own take on Fat Tire and released it as a limited-edition twelve pack, including the original Fat Tire, of course. The results were wildly creative and a refreshingly original idea for a mixed pack.

Sometimes, New Belgium collaborates with a completely different industry. In 2015, New Belgium brewed a beer in collaboration with Ben & Jerry's, a Vermont-based ice-cream company. Both companies are known for their environmental activism and charitable nature, which made this project all the more special. Each company produces a flavor called Salted Caramel Brownie Brown Ale, and a portion of the proceeds was donated to Protect Our Winters, a

Iconic signage at New Belgium's entrance. *Gus Hoffman.*

New Belgium's main campus and biergarten. *Gus Hoffman.*

charity founded by winter-sports enthusiasts who want to create ways to combat climate change. The two companies are continuing this project in 2016 with Chocolate Chip Dough Ale, a golden brown ale (their description) scheduled for October release.[51]

With a brewery that has this much ethical substance, creative brewing and community activism, it's hard to keep up with what's happening next. Know this: the next twenty-five years will likely continue at this pace, so I suggest checking in every so often, catching a New Belgium event from time to time and, mostly, just sitting back and having a beer.

Fort Collins Brewery

From Berger to Banshee to Brewpub

In 1992, Sandy and Karen Jones caught the brewing bug. They'd seen some of their friends, including Doug Odell, have some success, so they hoped to capture this "new" industry's magic. They opened H.C. Berger Brewing and, with Sandy as its brewer, were successful in the area. Unfortunately, the Joneses decided to sell in 1996. H.C. Berger Brewing continued for another six years, eventually closing in 2002. The Joneses, after spending their mini-retirement tinkering with classic cars, home-brews and cooking, decided to swoop in and restore the brewery they'd created a decade before.[52]

This time, they recruited their friends and fellow foodies Dave and Janet Scott to partner in the venture. They went about the business of rebranding: new name and new beers. They did purchase the old H.C. Berger space at 1900 East Lincoln Street, which reemerged in 2003 as Fort Collins Brewery, a German lager house. The first new beers were Edgar, a Marzen/Oktoberfest lager; Doktor, a Helles lager brewed with Tettnang and Mount Hood hops, and Z lager, a Rauchbier (smoked lager). While the brewery was building steam, it seems that four owners may have been too many cooks in the kitchen.[53]

It was about that time that Tom and Jan Peters entertained the idea of purchasing the newly restored brewery. Tom had a background in the manufacturing business, so this venture was a significant departure. His daughter Tina, in her early twenties at the time, was surprised by her father's "retirement project." Nevertheless, the family embarked on this new business (Tina worked in the taproom to start), and it seems that Tom and

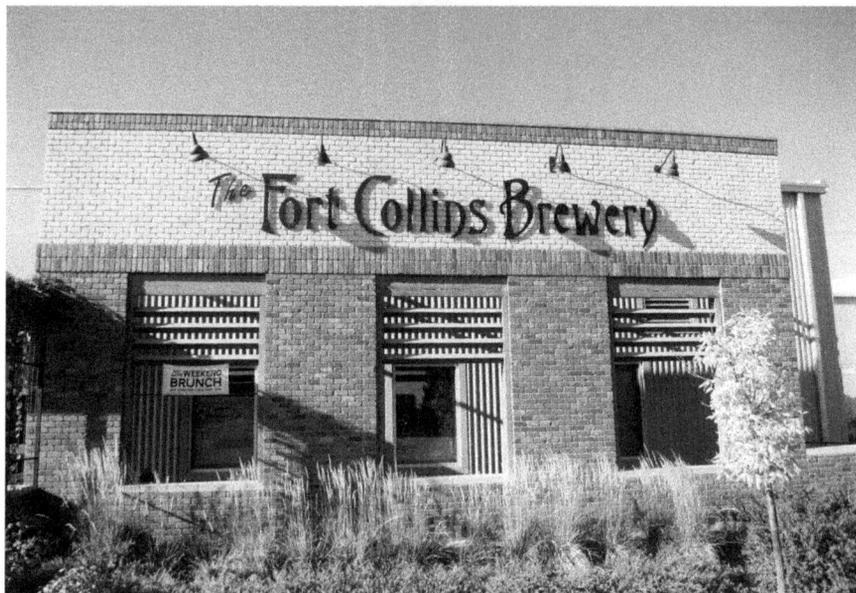

Outside Fort Collins Brewery, located at 1020 East Lincoln Avenue. *Gus Hoffman*.

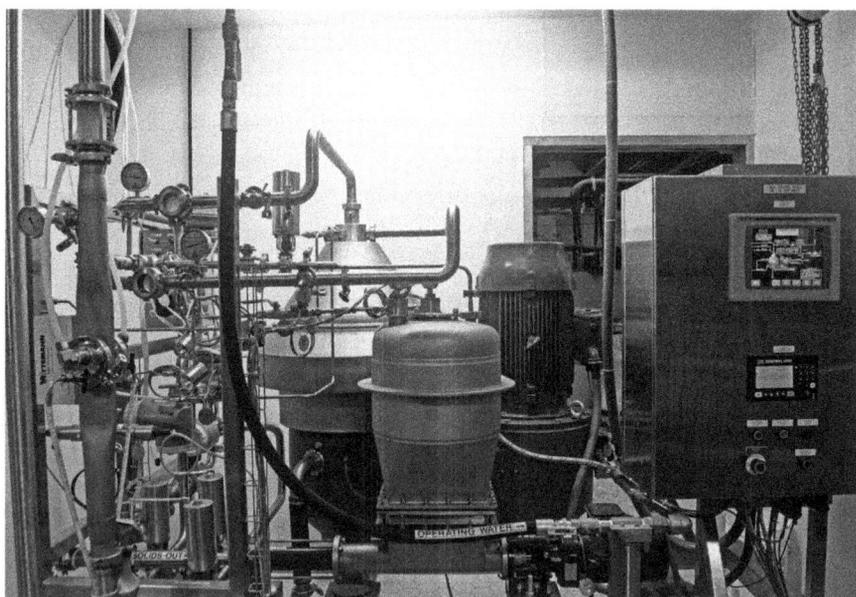

Centrifuge at Fort Collins Brewery. *Gus Hoffman*.

Jan's business acumen was just what the brewery needed. Sandy Jones stayed on as the brewmaster until 2008.[54]

In that time, the German styles flourished, and there was also a return to some H.C. Berger favorites like Red Banshee, Chocolate Stout and the Kolsch. Red Banshee went through many incarnations over the years. It became Retro Red on one of its returns. The original artwork, created by Jan Peters, featured a little red wagon on the bottle. Unfortunately, a rather large producer of little red wagons believed the image bore too close a resemblance to its product to allow Fort Collins Brewery to continue to use the name and likeness. Red Banshee's current incarnation is actually now an altbier, not the red ale it once was many years ago.[55]

As Fort Collins Brewery (FCB) continued to grow, the Peters family soon realized that the brewery and taproom were in need of an upgrade. In August 2010, the brewery moved down the street to its current home at 1020 East Lincoln Street, a facility three times larger than its first. This taproom had enough space to accommodate a full-fledged tavern, a new project that captured the interest of the Peters.

The tavern opened just ten months later, committed to fresh, local fare. This aspect of the brewery really does set FCB apart from other breweries in the city. The tavern is, of course, a taproom, but it also offers local, handcrafted comfort

Side image of Fort Collins Brewery. *Gus Hoffman.*

Entrance to FCB's taproom. *Gus Hoffman.*

food. All the condiments are made daily with no preservatives or added sugars. Produce is even grown on the premises in a greenhouse and rooftop garden.

Nearly all of the establishment's grass-fed beef and cheese are sourced from farms less than forty miles away, and 80 percent of all ingredients are local. The kitchen has no microwaves or freezers. If one begins with quality ingredients, the outcome has a much greater chance of being a superior product. This commitment to quality is representative of FCB's overall belief in the community: its farms, its businesses and its people. The space itself was built with community in mind, because FCB believes that beer is best enjoyed with a social component. One side of the tavern features a long community table for folks to meet other beer lovers or to facilitate events.

Sustainability measures don't stop in the tavern, of course. FCB's brewing operation built in many energy-saving tools. The brewery has an organic containment drain system to keep beer byproducts from entering the city's wastewater system, thereby reducing the energy required to treat the water. It also invested in a fifty-barrel Rolec Automated brew system that reduces the use of water down to 5.3 barrels per 1 barrel of beer produced. The addition of the GEA Westfalia centrifuge eliminated the need for diatomaceous earth filtering, also known as DE filtering. Many breweries filter their beer using this organic product made from fossilized diatoms because it is effective in fining without affecting the color or flavor of the beer, but it can require a significant amount of additional water usage and waste. The centrifuge saves six thousand pounds of waste every year. Rather than using air conditioning to keep the beer cool in the brewery, FCB installed a series of automated louvers and exhaust fans to utilize outside air at advantageous times. They exhaust warm air during

the day and open the louvers at night to capture cool air. Spent grain is donated to local cattle farms for use as feed.[56]

Conservancy can continue even after the beer is brewed. The sales team drives a fleet of Smart cars to minimize the carbon footprint. While 70 percent of FCB's beer is sold in Colorado, it does offer distribution to seventeen other states. The brewery coordinates with other breweries' shipments to essentially "carpool" beer, curtailing everyone's environmental impact. One of the most significant changes in recent years was the shift to an all-canning production line. The decision was based on streamlining the process and eliminating unnecessary packaging that comes from producing glass bottles. (Glass bottles need cardboard six- and twelve-pack holders, paper labels, etc.) Aluminum cans have gained popularity over the years with beer enthusiasts because they offer 100 percent protection from light (no skunky beer!), are lightweight, easily recyclable and can be taken many places that discourage glass, such as pools and outdoor venues.[57]

In 2014, Tom and Janet Peters included their daughter as a co-owner. Tina Peters had worked for the company since she was just twenty-two years old, making her a natural choice to continue the family-owned business. Under her leadership, FCB embarked on many new ideas: the aforementioned exclusive canning line, some recipe revamps and a barrel aging/sour program. Tina's fresh approach allowed the brewery to keep its roots while remaining flexible enough to move with the changing trends. This brewery has excelled in evolution and flexibility. Even in the time that the Peters family has owned and operated FCB, they have made great strides in shaping and changing their product and concept while evolving with the palate of the increasingly sophisticated audience. This was evident while speaking to Tina. She recognizes that the beer-drinking community has expanded beyond the older beer enthusiasts whose palates grew with the emerging availability of styles and who remember the days of a limited market dominated by adjunct lagers. Today, the new generation of beer drinkers can gain aficionado status in their early twenties, having come of age in a culture in which their elders may already be well versed in the vast landscape of beer options. The brewery is playing to that, and not staying safe.[58]

The Savor Series program, launched in 2014, took about two years to come to fruition, given that these are aged and inoculated varieties. The first beer of the series was the American-Style Barley Wine. This brew is substantial at 10.5 percent ABV, but it really highlights the hop characteristics, which defines this as more American than English. Despite its high alcohol content, the ale is remarkably drinkable. The nose is resinous, with tropical fruit elements and a very smooth finish.

Hopper in Fort Collins Brewery. FCB moved into its current space in 2010 in order to expand. *Gus Hoffman*.

In September 2016, Fort Collins Brewery released its Oud Bruin, or "Old Brown." This style originated in Belgium and is also known as a Flanders brown. Characteristics of the style include a sweet/tart flavor with varying degrees of balsamic vinegar on the palate. The brewery's incarnation is pasteurized and took nearly two years to produce. It is a combination of three ales, according to FCB brewer Taylor Krantz, "one that has been soured for 21 months in barrels, another that's been souring for a year, and one that has aged six months but without souring agents."[59] The company withheld a portion of this Oud Bruin to use in future Oud Bruin releases, meaning that a portion of the original will flavor all the incarnations to come. What makes this release most revolutionary? It is canned and intended to age. The beer is can conditioned and will undergo secondary fermentation in the can, thus changing the product as it ages.

FCB has made a concerted effort to give back to the community that has supported it over the last twelve years. The brewery hosts two weekly brewery yoga classes, which include a one-hour yoga instruction followed by a choice of FCB brew, beermosa or Bloody Mary. Over half of the proceeds for the event are donated to the FOCO Café, the area's first nonprofit restaurant. FOCO Café's goal is to offer local, healthy fare to all of the community's citizens, regardless of their ability to pay. All menu

Aerial view of Fort Collins Brewery production. *Gus Hoffman.*

pricing is donation-based, and the restaurant space is also available for meetings on a donation basis. Fort Collins Brewery has also sponsored the Malt Monster 5K, a fun run that donates a portion of every registration to the FOCO Café as well.[60]

The city of Fort Collins has an unusually high number of women in ownership and brewery positions, and this brewery is no exception. Clearly, the business is primarily female-owned, and Tina Peters estimates that about 65 percent of her total workforce is female.[61] When asked about this high percentage, she simply said it comes down to "who is the best candidate." It is a striking example of many breweries in the area. Given the majority of women involved, it developed a program to encourage more female involvement, called Hoppy Ladies Beer Club. Members meet at Fort Collins Brewery every fourth Wednesday to discuss a wide variety of beer and brewing topics. Many other women in the brewing community participate by leading discussions. The topics depend on the requests of the current group. Topics range from basic to highly technical, but the idea is for the group to remain accessible to the newest members. For example, Lauren Woods Salazar, master blender for New Belgium's wood-aging program, spoke to the group about blending sour and barrel-aged beers.[62] While this was a hugely popular and successful event, more elementary events regarding beer styles and basic brewing queries are also offered. It is intended to be, on most occasions, an open forum for asking questions and gaining confidence and knowledge.

At its core, Fort Collins Brewery is about creating, sharing and savoring. It not only creates beer but also fosters a space that is intended to cultivate creativity in others and a social environment to share. Great beer begets great ideas; people feel a little more creative, or at least a little less inhibited, after a beer or two. Sometimes, stripping away our inhibition is a great way to see what we have to offer. Once these sparks of ingenuity are firing, a beautiful and interesting conversation can grow: maybe among old friends, or perhaps with a new acquaintance. This sense of community is the lifeblood of pubs and taverns worldwide and is a great aspect of experiencing this space. Most importantly, Fort Collins—brewery and city—put a tremendous amount of time and effort into their creations. They are meant to be savored. There are few earthly pleasures quite like fully experiencing a beer: admiring its color, breathing in the aroma of the foamy head, letting the flavor and viscosity revel on the palate, becoming ever more varied and complex until its finish. It is a sensory experience that should make a person grateful to have that capacity. Enjoy it while you can, folks.

Part III
The Next Generation

Fermenters and mash tun at Horse & Dragon. *Gus Hoffman*.

The Horse & Dragon logo on the front of the brewery is symbolic of the company's ties to both the East and West. *Gus Hoffman*.

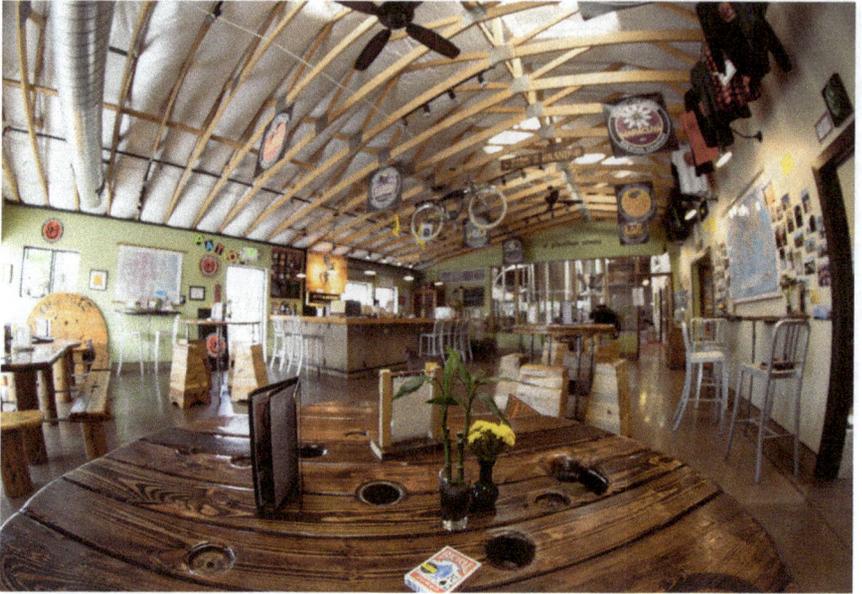

The inside of Horse & Dragon's taproom is warm and inviting. The company wants visitors to have a sense of being part of the "family." *Gus Hoffman.*

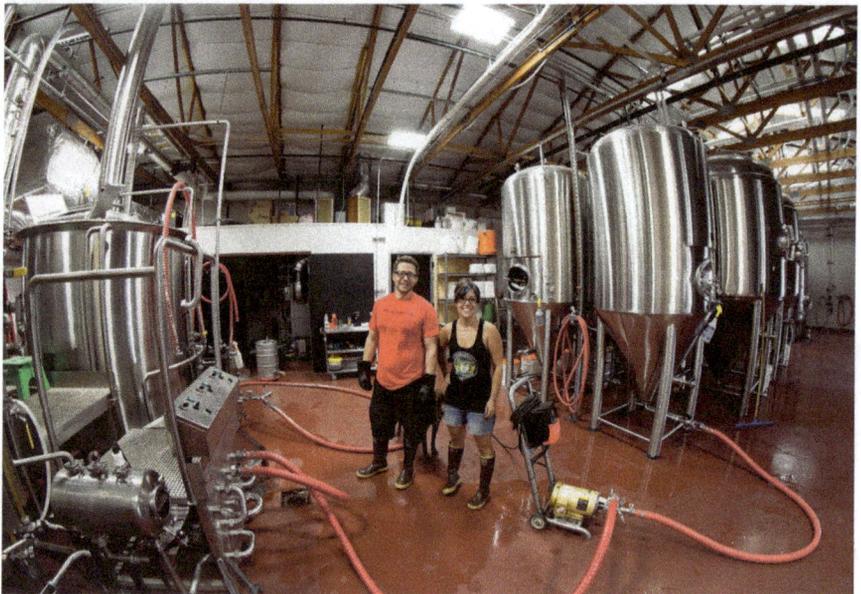

Head brewer Linsey Cornish with fellow Horse & Dragon employee. *Gus Hoffman.*

Carol and Tim Cochran are the owners of Horse & Dragon. *Gus Hoffman.*

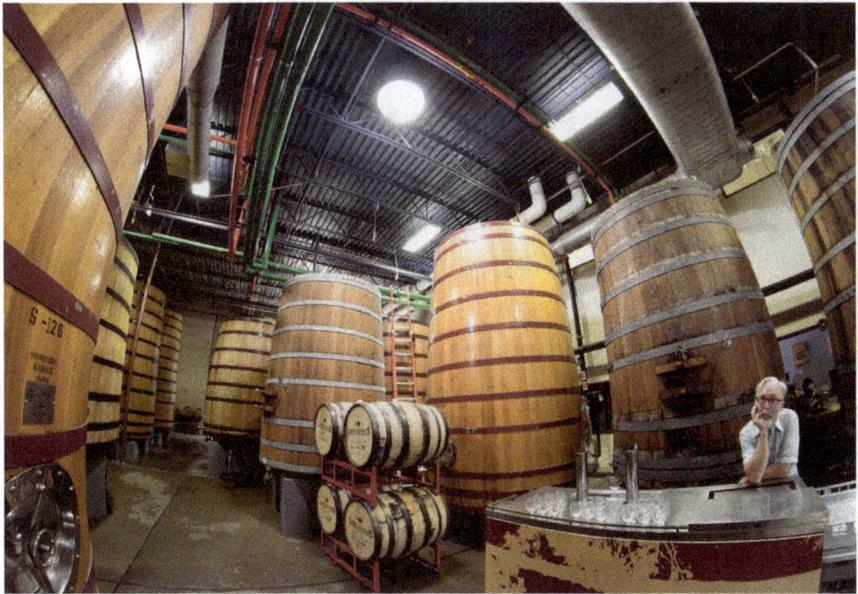

New Belgium's impressive barrel room is the second largest in the world. Bryan Simpson, the company's PR director, is also pictured. *Gus Hoffman.*

Left: Completed twelve packs of Citradelic IPA come off the production line at New Belgium. *Gus Hoffman*.

Below: Yeast cultures are essential to the varied styles of beer that New Belgium produces. This is the laboratory. *Gus Hoffman*.

New Belgium bottles, filled and capped, are ready to be packaged off the bottling line. *Gus Hoffman.*

The Funkwerks logo is displayed prominently on the front of the taproom. *Gus Hoffman.*

These are some delicious brews from Old Colorado Brewing Company's taps. *Gus Hoffman.*

Can stock for Fort Collins Brewery's production line. FCB has moved to an exclusively canning system for environmental and quality purposes. *Gus Hoffman.*

Local folks are enjoying beers at Fort Collins Brewery. The brewery's nine GABF awards are pictured in the left background. *Gus Hoffman.*

Brandon Neckel is one of Old Colorado Brewing Company's current owners and the grandson of Joseph Neckel, founder of the brewery. *Gus Hoffman.*

Left: Doug Odell, founder of Odell Brewing Company, and the author enjoying a tasty Odell brew. *Gus Hoffman*.

Below: Odell's bottling line was acquired from Flying Dog Brewery when Flying Dog made the move from Denver to Maryland. *Gus Hoffman*.

Brombeere Blackberry Gose and Drumroll American Pale Ale are freshly poured at Odell's taproom. *Gus Hoffman*.

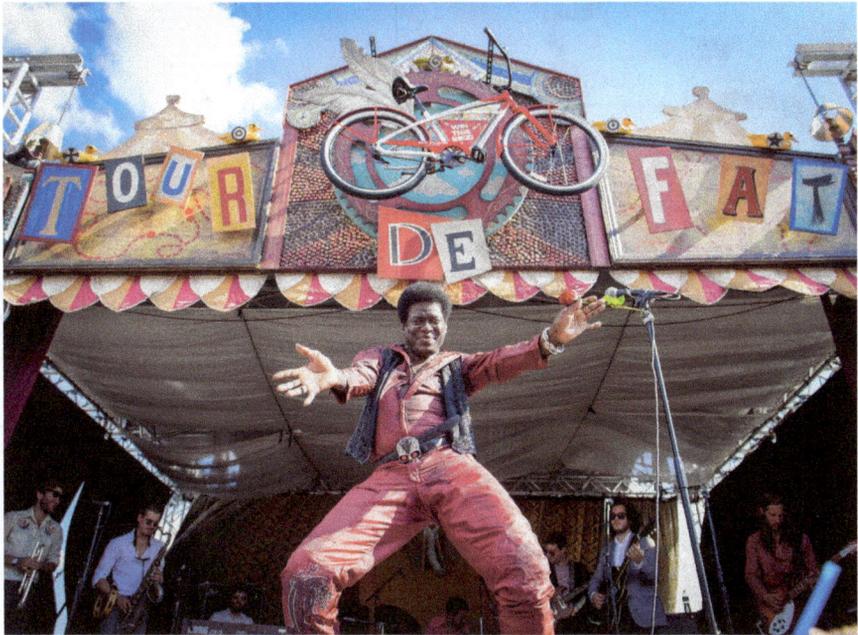

Another fantastic performance at one of New Belgium's Tour de Fat festivals. *New Belgium Collection*.

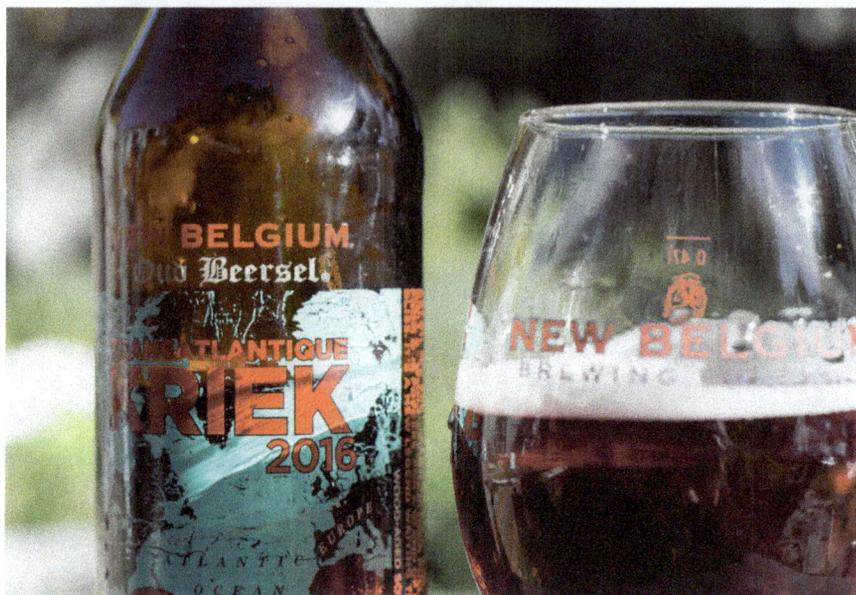

New Belgium's Transatlantique Kriek is an annual lambic-style beer brewed in collaboration with Oud Beersel, a legendary Belgian lambic brewery. *Gus Hoffman.*

Every year, New Belgium commissions a new design for its cruiser; this is the 2015 edition. *New Belgium Collection.*

The costumed bicycle parade is a long-standing tradition of the Tour de Fat festival nationwide. *New Belgium Collection.*

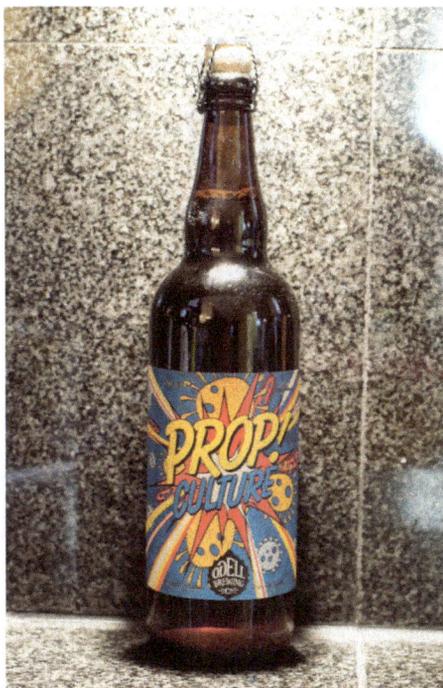

Odell's Prop Culture, a one-off, limited-edition ale released in the spring of 2016. *Gus Hoffman.*

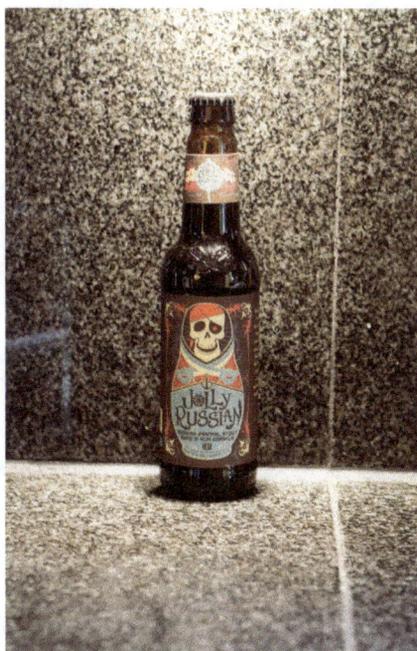

Odell's Jolly Russian was released on September 30, 2016, to Odell's taproom and at the Great American Beer festival the following week. *Gus Hoffman.*

Above: A globe of New Belgium's Abbey, one of the first beers produced by the young company. *New Belgium Collection.*

Left: Blue Paddle, a lager from New Belgium named by a community member, who became a New Belgium employee thereafter, following an open naming contest. *New Belgium Collection.*

Another scene from Tour de Fat. *New Belgium Collection.*

A Tour de Fat attendee enjoying a fabulous New Belgium brew. *New Belgium Collection.*

Left: A guide getting ready for tastings as part of the New Belgium Experience Tour. *New Belgium Collection.*

Below: When visiting the New Belgium taproom in Fort Collins, there's a beer selection for any palate. *New Belgium Collection.*

Horse & Dragon's Fire Captain, an Irish red ale. One dollar from every pint goes to the Firefighter Community Compassion Fund. *Carol Cochran.*

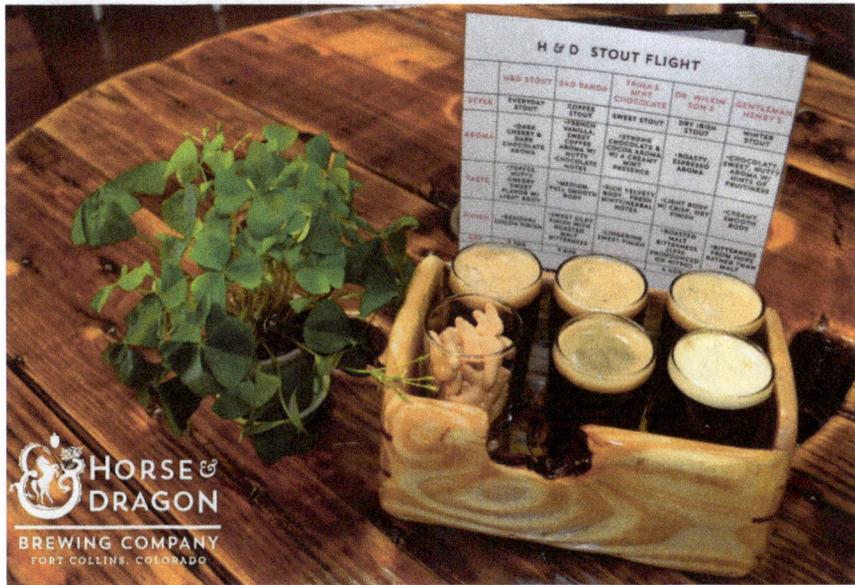

Horse & Dragon's stout flight. Any flight ordered comes in this adorable little wooden box, which also minimizes spills. *Carol Cochran.*

Lauren Woods-Salazar examines a New Belgium beer with her senses. Her palate is critical to the barrel-aging program. *New Belgium Collection.*

7

Noteworthy Newcomers

The three breweries we've discussed laid the groundwork for a new generation of breweries that have emerged in the 2010s. As of the end of 2016, about two dozen breweries live within Fort Collins's city limits. In this chapter, we celebrate a few breweries that have taken the torch and continued to set the beer scene ablaze.

FUNKWERKS

The Funkwerks story begins with its owners, Gordon Schuck and Brad Lincoln. Gordon was building bicycle frames in Steamboat Springs, Colorado for work and home-brewing for pleasure. He developed some solid recipes and was awarded a gold medal for his saison at the National Homebrewer Competition in 2007. Brad was working as an accountant in Portland; he had a love affair with great beer that began long before the authorities need to know about. As fate would have it, they both chose to attend the Siebel Institute in the winter of 2009. They met while studying brewing science. After completing the program, the pair discussed opening a brewery together.[63]

Gordon was set on staying in the Centennial State, and Brad was somewhat familiar with Fort Collins due to a prior, unrelated visit. They quickly decided to call Fort Collins home, not fully realizing the benefits

Above: Funkwerks boxes in the packaging area within the brewery. *Gus Hoffman.*

Left: Funkwerks' iconic mascot, the tulip glass named Winky. *Gus Hoffman.*

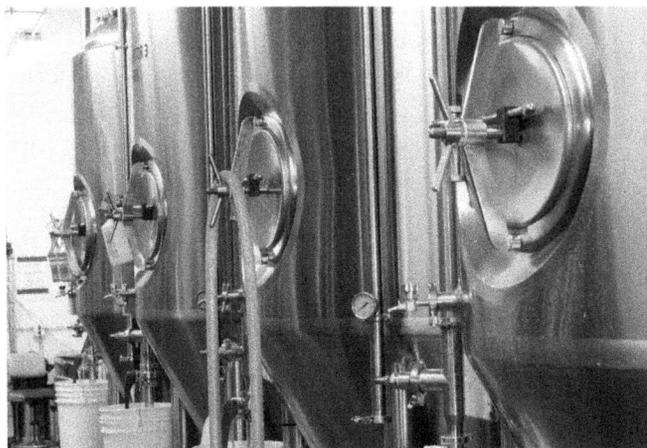

Brew tanks at the Funkwerks facility. *Gus Hoffman.*

Nick Jenkins works in production as part of the Funkwerks team. *Gus Hoffman.*

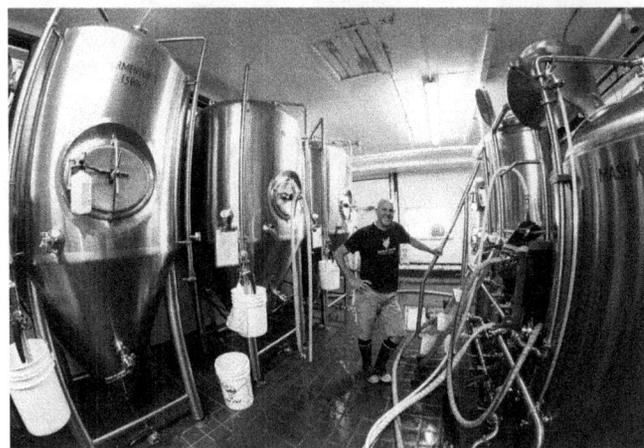

Fermenters, mash kettle and brewing assistant at Funkwerks. *Gus Hoffman.*

this city would hold. The new business partners participated with the local home-brewers club, where they met folks who would open and work for breweries like Equinox, Pateros Creek and Grimm Brothers. Over time, they have benefited from the tremendous sense of community that exists in Fort Collins. Whether it's access to some gently used equipment or a sounding board for ideas, the city is rich in beer resources. They knew they wanted to produce beer styles that they enjoyed, something that was underrepresented in the market. Gordon's aforementioned gold medal clinched the decision: the brewery would produce saisons and other Belgian-inspired varieties.[64]

Funkwerks, named for the funky, earthy saisons it produces, opened in the winter of 2010. It began with its flagship Saison, a recipe that varies from Gordon's original recipe, and Tropic King, an imperial saison. Tropic King was designed to be a hop-forward version of the flagship, but with the use of New Zealand Rakau hops, it took on flavors of passion fruit and mango, hence the name. The lineup expanded quickly in a few years, and the accolades quickly followed. In just five years, Funkwerks received three GABF gold medals, one GABF silver, one World Beer Cup silver medal and the Small Brewing Company of the Year award (2012).[65] The company was off to a pretty solid start by most measures. It continued to expand its

Not all of the barrels fit into the barrel room, but we're glad to see that program expanding. *Gus Hoffman.*

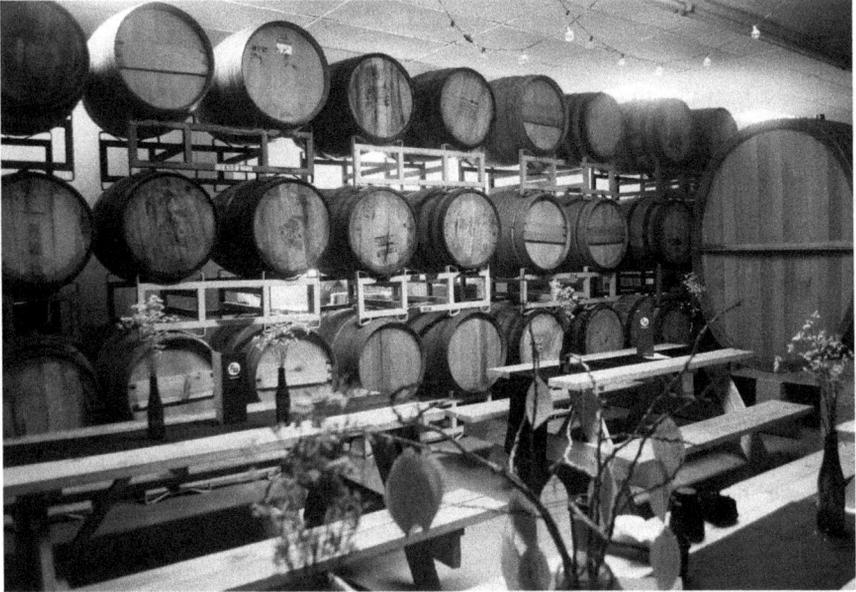

The barrel room at Funkwerks. This is a separate room off the taproom, where beer is aged and private events are hosted. *Gus Hoffman.*

portfolio with a kettle sour and barrel-aging program, which made for some fantastic beers and a lovely barrel room in the back of the brewery, available for private events. The company is using a wide variety of used barrels, like cognac, rum, whiskey and port. As of the end of 2016, it was distributing to five states: Colorado, Arizona, Minnesota, Iowa and Texas. Discussing plans for the future, Brad Lincoln talked about continuing to expand distribution to more states and increase production of fan favorites like Raspberry Provincial, a low-gravity Belgian-style fruit ale that earned the brewery one of those Great American Beer Festival golds. In 2016, it produced just fewer than six thousand barrels; its facility caps out at around eleven thousand or twelve thousand barrels.[66] Because of this, ownership is thinking critically about expansion beyond the walls of the current brewery and taproom (currently at 1900 East Lincoln). A decision regarding expansion will likely take shape in the next couple of years. At that time, the brewery hopes to incorporate greater sustainability and conservancy measures. In these last six years, the focus has been on producing niche beers of outstanding quality. While "green" measures are important, don't expect this aspect to be a marketing talking point. This crew is full of solid beer geeks, and they keep their eyes on that prize.

Horse & Dragon

Our next brewery, the brainchild of Carol and Tim Cochran, was over twenty-five years in the making. This couple met in school in Northern California and frequented the Tied House in Mountain View, California, in 1987 where they found two great loves: the love of each other and of craft beer. They married and spent their honeymoon in Napa Valley.[67] At this popular honeymoon destination, these two bucked the trend and spent every dinner at a taproom or brewery, planning their future endeavor. They traveled abroad, living in Asia and Colombia for years at a time, always scouring the landscape for great beer. As it happened, these corners of the world didn't really lend themselves to spectacular beer at the time, which led Tim to home-brewing. No matter where they lived, they always returned to Fort Collins annually. Carol had family in the area, and her grandparents had worked at Colorado State University since she was a child. She has always held fond memories of the Poudre Canyon. Visiting the burgeoning craft beer scene certainly didn't deter them, either.[68]

By January 2013, they had returned to Fort Collins to stay and began the concrete planning of their dream brewery. They settled on Fort Collins for sentimental and entirely logical reasons (great water, community and thriving beer scene). The original plan was for Tim to brew, but they quickly settled on finding a brewer who had more experience with a commercial-level brew.

Horse & Dragon's Brewery and Taproom, located at 124 Racquette Drive. *Gus Hoffman.*

Barrel program at Horse & Dragon. The flags on the ceiling indicate countries where Carol and Tim Cochran resided. *Gus Hoffman.*

After an exhaustive nationwide search that included flying the top candidates out from across the country, the best one for the job turned out to be working down the street, more or less. Linsey Cornish had previously brewed at Odell to much acclaim. There are many anecdotal stories of locals who made a special effort to get to Odell's taproom on her firkin release days. Now, as head brewer, she has been given carte blanche by the Cochrans to create innovative, balanced, food-friendly beers. There is not a particular theme to this brewery in terms of beer style, so the opportunities are innumerable. "We just hope we can keep her happy," says Carol Cochran.[69]

In May 2014, they opened their doors to the public as Horse & Dragon Brewing Company. The name carries significance in multiple ways. It is a nod to the far-reaching places the Cochrans have called home over the years: a horse is a symbol of the Wild West spirit that exists in Fort Collins today, and the dragon is a time-honored symbol in many Asian cultures as water deities or harbingers of good fortune. It can be seen as auspicious that January 2013 was the end of the Chinese Year of the Dragon and May 2014 was solidly in the Year of the Horse.

With the examples set by the larger breweries in the area, sustainability and conservancy were major principles of the brewery from the beginning. The Cochrans joined local organizations such as BreWater and Climate

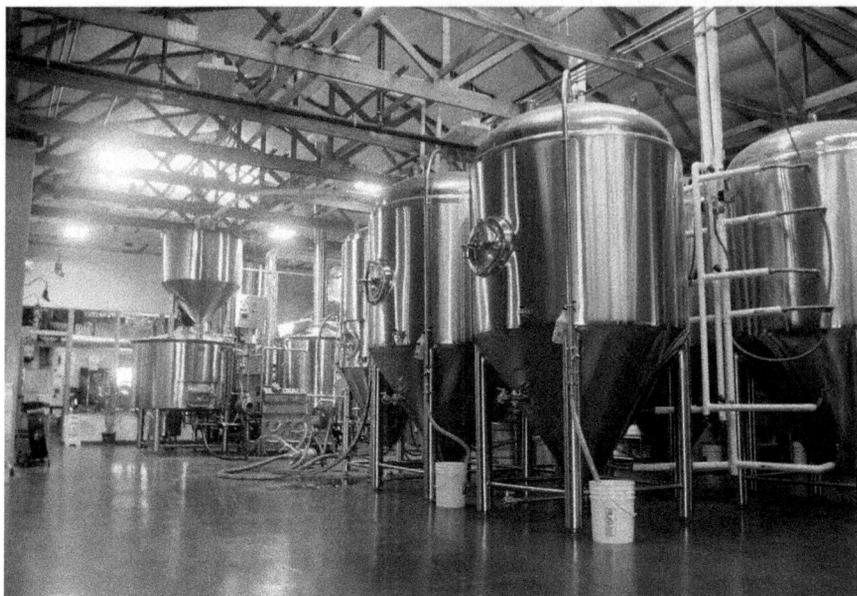

Fermenting tanks at Horse & Dragon. *Gus Hoffman.*

Wise to get advice from the community and begin their business with the right tools. The brewery/taproom is housed in a former airplane hangar, so the remodel was extensive. It afforded them the opportunity to implement these green measures from the start. Remember, they'd been thinking about this project for a couple of decades, so ideas were plentiful. They installed additional skylights and LED lighting to minimize the need for lighting and reduce the energy used when it is needed. The Cochrans invested in a forty-five-barrel hot liquor tank (they'd planned on a thirty-barrel tank) so that they could capture the water from cooling the wort, thereby making it available to reuse. The brewery reflects detailed planning, like the drought-resistant landscaping, low-flow bathroom facilities and the use of cable spools to construct the furniture in the taproom. The Cochrans are also transparent in their desire to improve. The website divulges their use of a gas-fired boiler and then solicits advice on how to minimize usage.[70]

Horse & Dragon values giving back to the community that has offered so much to them. The owners' travels gave them time to ponder what kind of business they wanted to create. They definitely wanted an establishment that brought people together and valued community involvement. The brewery frequently donates beer and a portion of its proceeds to local charities. In fact, each of the owners and Linsey have their own favorites.

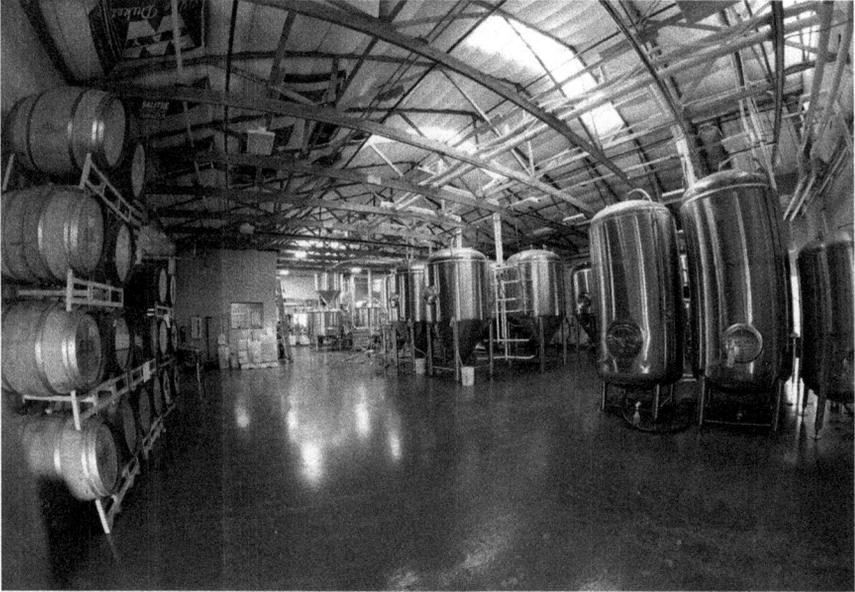

A panoramic photo of Horse & Dragon's brewery. *Gus Hoffman.*

Carol's is a unique child literacy program called Book Trust. Remember the Scholastic book orders from elementary school? Many people have fond memories of selecting books, which would be delivered to the classroom in four to six weeks, just enough time for it to be a welcome surprise. For a kid, it's one of the first opportunities to make unilateral decisions on content and to own something that helps them practice reading and gain new information outside the classroom. This charity helps pay for books for Fort Collins children whose families don't have the luxury of discretionary spending, even when it comes to educational materials. In 2016, the brewery began sponsoring a half marathon and, for those more interested in drinking than running, a Pint Run (1.6 miles), the proceeds of which benefit Book Trust.[71]

More than anything, Horse & Dragon wants to be known as the kind of place that makes you feel like family. When visiting the taproom, there will likely be a beer on tap to satisfy any palate: a couple IPAs, a couple stouts (Sad Panda is a favorite), maybe a saison, an English-style ale and more. The taproom is warm and friendly. Grab a box of tasters and find out what suits you.

ZWEI BREWING

This story begins with another important brewery. Brothers Kirk and Eric Lombardi worked at C.B. & Potts for about twenty years. Kirk expresses a lifelong fondness for German and Bavarian beers. When the craft market was lean, many of his favorites were German imports. He continued to cultivate that passion into his brewing. They brewed together and won their first medal (silver at GABF, no less) brewing a bock.[72] When the brothers finally visited Germany for Oktoberfest, it was that moment of epiphany where they realized that this is what they were meant to do: bring this beer experience to the States. In 2014, they set off on opening Zwei Bruder ("Two Brothers" in German). This name didn't last long, as it infringed on another American brewery with a similar name.[73] Hence, Zwei Bruder became Zwei Brewing and opened in August 2014. The brewery's commitment to creating authentic German styles was wholehearted and thorough. It has horizontal lagering tanks, and all of its ingredients, except the water, are imported from Germany. It adheres to reinheitsgebot on all of its German-style lagers, Reinheitsgebot ("German Beer Purity Law") essentially dictates that beer include only water, hops and barley. Its most famous incarnation was adopted in Bavaria in the sixteenth century, though other embodiments of the law existed prior to this time. There are other guidelines, but that is a topic for a different book. In any case, Zwei is taking this whole German beer thing pretty seriously, and it shows. The first beer Zwei brewed was its Helles, a Munich-style

Lager tanks at Zwei. This brewery has gone to great lengths to create a true German experience with its beer. *Gus Hoffman.*

Fermenters at Zwei. *Gus Hoffman.*

golden lager. German drinkers (and non-German aficionados) often remark on how accurate this particular beer is. A note for new hobbyists: lager beers, like pilsners, Helles and bocks, are often underappreciated in this country. Many new Americans of German descent opened breweries, and the breweries that survived Prohibition were largely of that lineage. The resulting products became styles unto themselves (American lager, etc.), but because of this connection and the shift from what was known to the new and exciting styles that followed, many people do not know how challenging a lager is to produce. When your beer is only hops, water and barley, there is nowhere to hide. Faults are evident, and there is little or nothing that can be done to mask it.

While they are certainly the flagships, Zwei has not limited itself to spectacular German-style beers. When the Lombardi brothers visited Germany and the Czech Republic, they noticed that small breweries and home-brewers in the Czech Republic were not only producing the regional styles but also trying their hand at American and Belgian styles. They didn't see this in Germany, likely due to Reinheitsgebot. This gave them the inspiration and, perhaps, latitude to explore varied styles without the guilt of straying.

Half of the tap list at the brewery generally consists of German styles (Flagship or Continental Selections). The other half are "experimental" (Indigenous Selections). One such Indigenous Selection is Dr. Bill, a fresh-hopped extra pale ale. Dr. Bill Bauerle grows the fresh CTZ hops hydroponically on the Colorado State University campus. The result is a fresh, herbaceous brew that is not at all tannic (38 IBUs, or International Bittering Units) and truly a community project. Another beer that involves

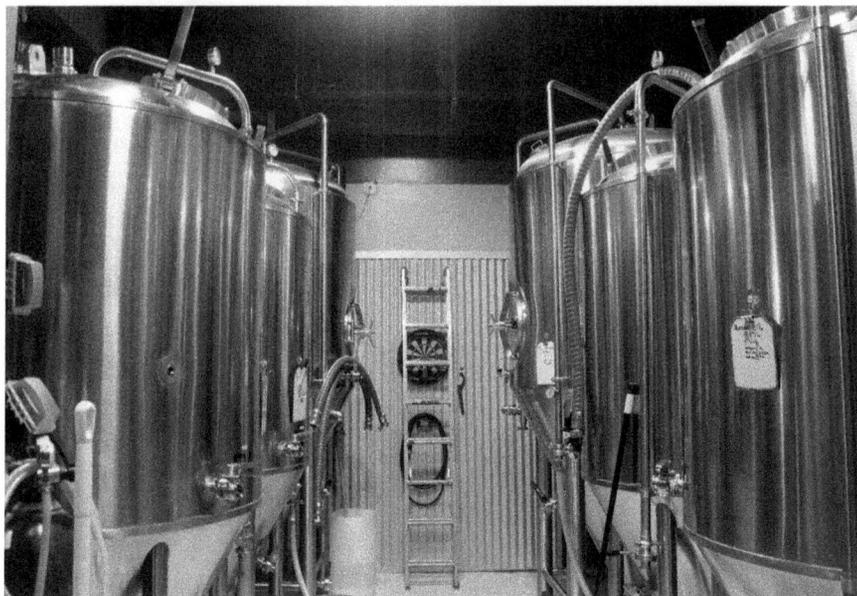

Helles and the Golden Hammer (a Belgian strong ale) are brewing at Zwei. *Gus Hoffman.*

the locals is Golden Hammer, a Belgian-style golden strong. This is a Pro-Am collaboration with Alex Grote, the president of Liquid Poets, the local home-brewers association.

The brewery is one of a few on the south end of town, but it is worth the excursion. The taproom consists of indoor and outdoor community benches, biergarten style. This is a brewers' brewery, but it is also incredibly accessible. If you aren't familiar with a particular style, try it. Even if it's not for you, it won't disappoint.

THE NEWEST OF THE NEWCOMERS

The Fort Collins brewery scene continues to multiply every day. This section is dedicated to those breweries that have embarked on their journey in the last two years. Time will write a larger narrative for all of these breweries, but for now, this is a simple nod to the new kids on the block.

Snowbank Brewing opened its doors on August 22, 2014. Dave Rosso, owner and head brewer, had a vision of innovative beer combined with his passion for the Colorado lifestyle. The brewery's tagline is "Beer. Elevated." The styles vary, but the flagship beers are Colorado Red, an American-style red

ale heavily influenced by an array of hops, giving it tropical, resinous and citrus notes; and Crankenbrew, a coffee-infused pale ale made with locally roasted coffee. Both are available at the brewery and in bombers to take home. All of the company's beers are unfiltered and vegan, with no added preservatives. The taproom has a cozy, all-ages atmosphere with games and nonalcoholic beverage options. It has a dog-friendly patio during the summer months.

Rally King is the brainchild of Matt and Michelle Kriewall. Originally from California, the Kriewalls met over a shared passion for rock climbing and athletic pursuits. After they wed in 1996, they quickly moved to Fort Collins, a city they fell in love with after a previous rock-climbing excursion. Matt opened a chiropractic practice in town, and the family settled in their new surroundings. In 2009, Matt Kriewall started home-brewing as a hobby. He quickly became quite accomplished, earning over eighty awards in various home-brew competitions over a three-year period. With Michelle's support, Matt decided that this wasn't a passing fancy; he had a talent that he wanted to share with the community. Thus, Rally King was born in 2015. The unusual name carries great meaning for the Kriewalls. The idea comes from the verb "to rally"—essentially, being the greatest when it is time to rise to the occasion, to take risks and face challenges squarely. Certainly, the Kriewalls' athletic, competitive nature shines through in a good-natured, "Eye of the Tiger" kind of way. One of the brewery's most popular beers is Surfer Girl, an American IPA. Kriewall created the recipe as a home-brewer, and it won first place at the Taste of Fort Collins home-brewer IPA competition in 2014.[74]

Three Four Beer Company is located across the street from the Colorado State University campus. The brewery is owned by Will Overbaugh, who also owns Road 34, a fun-loving bar that marries love for biking and for beer. The free-spirited, fun-loving attitude of Road 34 has spilled over into the new brewery. It opened on November 6, 2015, with Greg McDaniel at the helm. He studied brewing at the Siebel Institute in Chicago. Under McDaniel's tutelage, Wiley Gellar has now taken the reins as head brewer. While the company tends to focus on hop-forward recipes like IPAs and pale ales, Protester Porter is definitely a foundation beer for the young brewery. Its name was inspired by the frequent protests the founders have witnessed at the Planned Parenthood facility adjacent to their location. As they say in the beer's description, "We may not agree with their point of view, but we respect the right to have their voices heard."[75] The taproom has forty-nine taps; house beers account for six to eleven options at any given time. The rest are occupied by local and national guest breweries, with special attention placed on having a few sour options available regularly. The founders are grateful for the warm reception they have received from patrons, and they speak of the tremendous camaraderie among the local breweries.[76]

The story of McClellan's Brewing Company began in Canyon City, where Matt McClellan owned a pub for many years. After some time, the family was ready for a change in scenery and thought Fort Collins was just the right city to expand their pub into a brewery. Matt McClellan, along with a silent partner, decided that the new brewery would focus on beers that would be a nod to his roots. McClellan's Brewing Company produces only cask-conditioned Celtic-style beers. The partners also decided to create a legacy and give part ownership and managing responsibility to their sons, Joey McClellan and Josh Landry. They opened on November 15, 2015, and hired Graham Hirstwood, a native Scotsman, to brew these very traditional ales. The Kilt Tilter (say that quickly after a few) is their cornerstone brew and, not surprisingly, a Scotch ale. This rich, malty ale is brewed with Fuggles and East Kent Golding hops. The brewpub also offers eighteen local guest taps and a lovely sampling of charcuterie boards and sandwiches, all produced with the highest-quality meats and cheeses that Joey McClellan, who comes from a culinary background, can find.[77]

Jessup Farm Barrel Room also opened in November 2015, with the concept of producing approachable barrel-aged beers. Often, when people think of barrel-aged beer, a bourbon barrel imperial stout might come to mind. While delicious and available at Jessup Farm, that can be a bit intimidating for the burgeoning hobbyist. For example, Sangriaweizen is a red-wine, barrel-aged wheat ale with blackberries.

Jeff Albarella studied at Siebel Institute and became assistant brewer of Carver Brewing Company in Durango, Colorado, and then head brewer in 2012 before moving to Fort Collins to start on his own. With his friend Brad Lincoln of Funkwerks sharing an interest in his vision, the dream became a reality. On December 17, 2016, Jessup Farm Barrel Room released its first bottle, called First Anniversary, a peach golden sour ale.

Maxline Brewery is the newest brewery, having opened in June 2016. Kevin and Cathy Gerhardt had a passion for craft beer and community that spurred them to open a brewery with approachable yet innovative beers. Shawn Woodbury, the brewer, doesn't seem to confine himself to one particular style. His Winter Ale is less winter warmer and more fruit-forward, with a rosy hue. There are options in the taproom for all kinds of enthusiasts, from a traditional American Pale Ale to the Raspberry Basil Saison, made with six pounds of fresh local basil. This brewery also believes strongly in its responsibility to the community. It organizes events such as a Knit and Crochet Pint Night, in which participants are offered a free beer to utilize their skills to knit goods for Fort Collins families in need.

These new concepts continue to enrich the tapestry of Fort Collins's beer scene. This city has been a beacon for craft beer lovers, and the wealth of options continues to grow.

8

Shaping the Fort Collins Beer Culture

In the last twenty-five years or so, beer communities have emerged throughout the country, progressing the craft beer movement in leaps and bounds. While the beer industry is generally a creative and collaborative business, markets can vary in culture as much as cities do. In discussing these breweries individually, common threads have emerged and are the foundation of these guiding principles in the Fort Collins community.

Fort Collins is an environmentally conscientious community, and its beer industry is no exception. Larger breweries like Odell, New Belgium and FCB have gone to great lengths to promote conservancy, and the smaller breweries are following suit. Anheuser-Busch's Fort Collins brewery has also made positive environmental impacts. In 2015, Anheuser-Busch performed an internal audit of its facilities in order to keep up with the company's environmental goals and found that Fort Collins was an area whose water resources are strained, due to the region's propensity for wildfires. This prompted the company to partner with the Nature Conservancy and commit $110,000 to improve forest conditions and restoration projects in the Cache la Poudre River watershed. Reducing the risk of fires improves the community and ultimately protects the precious water resources.[78] Again, water is critical to life and to the brewing process. Fort Collins is particularly fortunate, as there is no major commercial or industrial usage of the Cache la Poudre River upstream of the city. A pure water supply is one of many reasons breweries select a location. The larger breweries have an advantage in terms of financial resources to realize

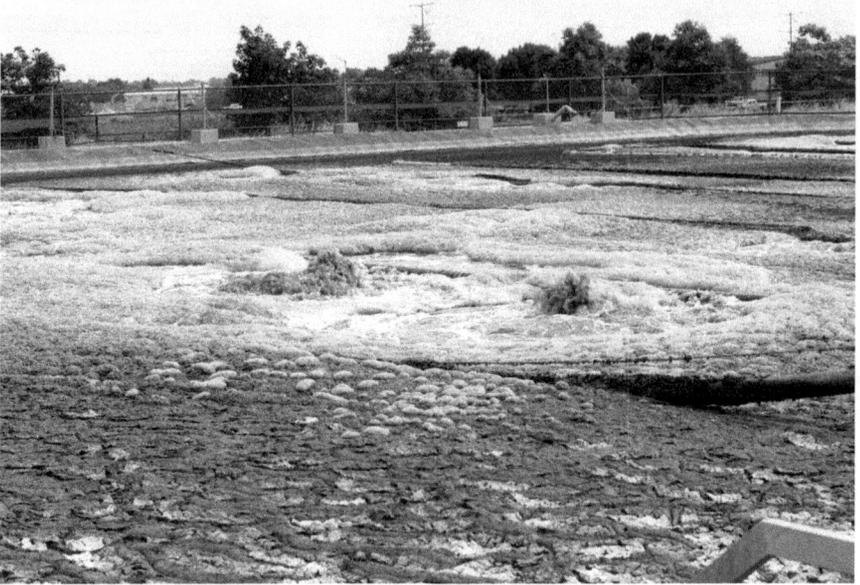

Part of New Belgium's wastewater treatment facility. This portion of the brewery is usually closed to the public. *Gus Hoffman.*

After the water is cleared of yeast and particulate, is it sent to the city's water treatment facility, ensuring no water is wasted. *Gus Hoffman.*

these goals. This has not stopped smaller breweries, like Horse & Dragon, from following their example. The brewing community understands the importance of this resource and works tirelessly to protect it. Many of the breweries have had water conservancy measures in place for years, but that doesn't stop them from continuing to raise their own bar. Breweries like New Belgium are constantly striving for environmental goals and creating new goals once the old are met.

Many breweries work with Climate Wise, a program through Fort Collins's city government. The program's sole function is to provide resources and recognition to commercial and industrial businesses. In 1999, the city passed legislation called the Climate Action Plan; this program was born from that commitment. The organization has lofty goals for reducing greenhouse gases in the city (20 percent by 2020, 80 percent by 2030) and becoming carbon neutral by 2050.[79] Businesses can earn badges based on efficiency measures undertaken, and those badges are compiled to give the business a rating of silver, gold or platinum. The levels are assessed annually. This desire for clean energy and conservancy is reflected in the brewing community largely because Fort Collins had made this concerted effort toward efficiency.

Another aspect of Fort Collins's brewing culture is the increasing number of women in the industry. In terms of history (or prehistory), women were the first brewers. That trend died with the pharaohs, but it is experiencing a mild resurgence, particularly in Fort Collins. Women hold ownership and brewing positions at all of the large breweries, including Anheuser-Busch Fort Collins, whose resident brewmaster is Katie Rippel. This is also the case at many of the smaller ones.[80] This trend was mentioned during several interviews with various breweries. The takeaway? Most of the female brewery employees, while aware that the industry is still largely male, have always felt welcome and accepted. This community is keen on diversity, and it benefits from that diversity by gaining new perspectives. Lauren Woods Salazar, New Belgium's wood cellar manager, sensory analyst and the creator of the Lips of Faith program, started working for the brewery in 1997, primarily as Kim Jordan's assistant. She came from a social work background and moved up the ranks at the young company, inventing positions that didn't exist prior to her filling them. While she doesn't fancy herself a brewer, she is instrumental in the blending and sensory process, part of what makes the finished beer.[81] She essentially created the brewery's sensory lab, a move that solidified the quality and consistency of New Belgium's flagship beers and afforded the company the opportunity to expand into the wildly creative array of options it now produces.

Aerial view of New Belgium's bottling line. *Gus Hoffman.*

Packaging line at New Belgium. *Gus Hoffman.*

This growing female input into the brewing process can only benefit the finished product, particularly when one considers the growing number of female craft beer enthusiasts. Northern Colorado has embraced this demographic, creating many beer clubs focused on the ladies: Fort Collins Brewery has the Hoppy Ladies Beer Club; the Mayor of Old Town, a tap house with an impressive tap list of one hundred beers, has the Beer Bettys; Ales4Females at Left Hand Brewing in Longmont; and the Can Can Girls at Oskar Blues, also in Longmont. These clubs offer an opportunity for women to come together and share their love of beer. It may sound silly, but there have been points in recent history when women have felt isolated in their hobby or avoided cultivating that hobby altogether. Hanging with the guys is great, but beer-drinking women have to be sought out. These organizations serve as a comfortable place to begin a beer journey; they can also be a place to get home-brew advice, learn something new or just enjoy a few beers with friends.

Fort Collins has a chapter of the Pinks Boots Society, an Oregon-based organization founded in 2008 by Teri Fahrendorf. The membership-based association works to support women in the brewery industry through continued education. It achieves this through collaboration, seminars and scholarship programs. Members brew together on special projects, culminating annually on Big Boots Day in early March to commemorate International Women's Collaboration Brew Day and International Women's Day. Chapters throughout the world brew beers and donate the proceeds to the organization.[82] The Fort Collins chapter has collaborated together on many projects throughout the years; it remains active within the community and in the society on the national level.

What truly makes the Fort Collins beer industry unique can be summarized by its sense of community. The level of fraternity and collaboration that this city shares is astounding. People share advice, raw materials and equipment on a daily basis. They even have a message board where they offer and seek resources. Theoretically, these people are in competition for market share and beer dollars. Not one brewery expressed even the slightest concern for this. It is not unusual to visit a taproom and be given recommendations on other breweries in the area. The idea is that if they all succeed, they all benefit. One great brewery does not make a beer vacation. People plan beer holidays based on their ability to enjoy a variety of styles and activities, so the more breweries Fort Collins has to offer, the better tourism is for everyone. Black Bottle Brewery has forty draft lines and frequently includes local competitors' beers. It is a smart idea, but counterintuitive to what we think of in terms of business.

Carol Cochran told a story about Peter Bouckaert, New Belgium's brewmaster, that encapsulates this idea perfectly. Bouckaert has a knack for selecting used barrels. He maintains that as long as he is present when they are opened, so that he can get that first whiff, he has a good idea of whether or not the barrel will be suitable for aging beer. Needless to say, this is an unusual talent. Bouckaert was on vacation in Northern California and had an opportunity to check out some "new" (used, but new to him) barrels. What he encountered were some spectacular specimens. He was so impressed that he not only bought for New Belgium, but sent a message to the Fort Collins beer community asking if anyone else wanted to buy in on these fantastic barrels. Many breweries took him up on the offer.[83]

Liquid Poets is the northern Colorado home-brew society. Members meet on the first Thursday of every month to discuss aspects of the home-brewing process (and to try each others' products). As mentioned in previous chapters, the commercial brewing industry has ties to this organization by way of members. Employees from Funkwerks, Grimm Brothers, Odell and other breweries have been members. Zwei recently collaborated with the president of the group, Alex Grote, on a beer. This kind of support gives hobbyists an outlet to learn and grow or consider moving in a professional direction.[84]

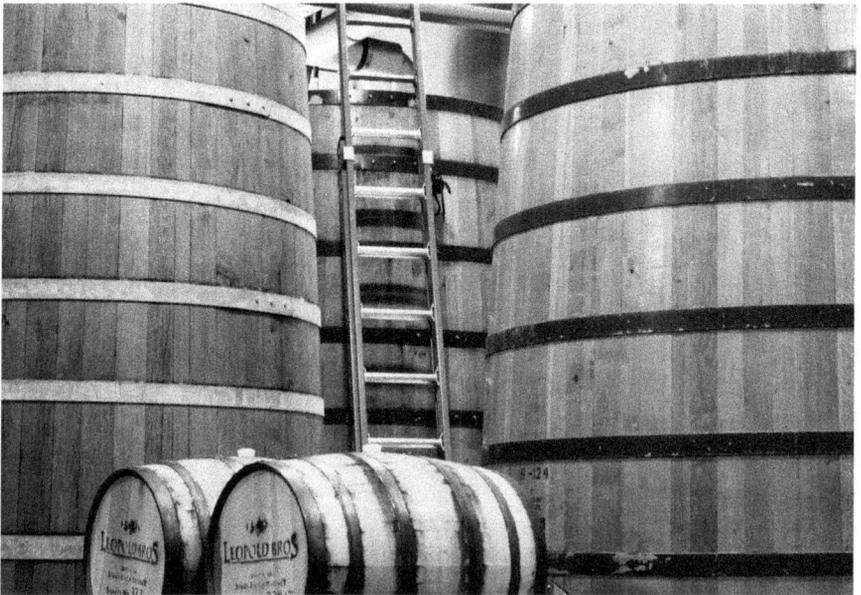

New Belgium's barrel room. *Gus Hoffman.*

A History of Brewing on the Front Range

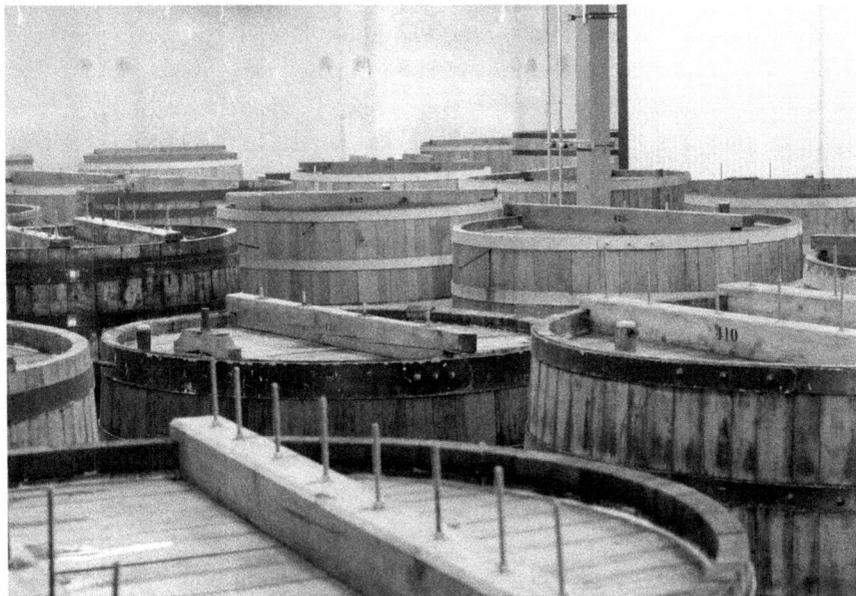

Aerial view of New Belgium's barrel room. *Gus Hoffman.*

Fort Collins's beer culture has a family-friendly element. One brewery that is known for its laid-back, all-inclusive atmosphere is Equinox Brewing. The story of Equinox takes us along a path of two folks who were shaping the beer culture long before they opened a brewery. Colin and Shannon Westcott, owners of Equinox Brewing, started their beer adventure in college in Missoula, Montana, where they met. Colin was an English literature major with a flair for science and brewing. He started brewing with the KettleHouse Brewing Company in 1997. After college, they set out on an adventure to Alaska. Colin got a job brewing at Midnight Sun in Anchorage. Once the couple decided to expand their family, it seemed wise to head back to the lower forty-eight to be closer to their extended family. Fort Collins was an area they both loved, for its proximity to family and its beer culture. They had many friends in the industry, and after a conversation with one such friend, it occurred to them that Fort Collins, with all of its breweries and pubs, had no home-brew supply store. With Colin's brewing experience and Shannon's mind for business, the duo opened Hops & Berries in 2005.[85] The shop has been very successful. It has expanded to two locations and offers home-brewing supplies, cheese and winemaking supplies as well as a variety of classes.

In 2010, the Westcotts opened Equinox Brewing. The brewery's philosophy is all about balance, as the name would imply. The balance of work and

play, malt and hops, and family time and hobby time is essential. The beer styles vary, from German fusion beers to big Belgian styles—quite a feat for their eight-and-a-half-barrel system. They are incredibly prolific in new styles, tapping a new beer one to three times a week. To date, Colin Westcott estimates that they have over 180 recipes. Colin Westcott started as the head brewer, but with the duties that accompany ownership, he found less and less time to do the thing he loved best. Jared Leyden, his assistant brewer since the beginning, became his official successor in 2015. The descriptors for these beers reference a wide variety of literature, poetry and pop culture, from "The Love Song of J. Alfred Prufrock" to *Seinfeld*. The menu is anything but dull. The Westcotts and Jared Leyden select the descriptors and beer names. They wanted the space to be comfortable; the most important aspect of this to the Westcotts is the lack of televisions. The space has become a community haunt, not just for beer drinkers, but also for people holding business meetings and local college students studying during the day. The Westcotts wanted a place where they would feel comfortable bringing their children, so the feel of the brewery is all-inclusive. The brewery offers root beer on tap for its underage guests, games and live music on the weekends and a beautiful beer garden during the warmer months.

Many breweries in town have taken to this model. In 2016, Black Bottle started something called Toddler Tuesdays, an event that allows patrons' children to eat free. Most patrons were thrilled at the inclusion, while others felt children and beer simply do not mix.[86] The idea is to give parents an opportunity to responsibly enjoy local craft beer and food while having family time. Most festivals in the area are also family-friendly events with music, food and nonalcoholic beverage choices.

Fort Collins has a group that encapsulates the fundamental idea of this family-friendly idea: Beers and Boobies, a meet-up support group for new mothers and their infants. Having a child can be alienating and a period of life when parents can lose their individual identities in this life-changing event. The idea of this group is to create a bridge between being an adult and being a parent and to connect to a community of people living these changes together. Every third Wednesday after work hours, the collective becomes Parents and Pints, an inclusive group for all parents.[87] Even breweries that don't tout their family friendliness see the benefit of being inclusive. Fort Collins breweries are not bars and don't want to be. There is an argument for children growing up in an environment where they witness responsible alcohol consumption paired with shuffleboard or a spirited board game the whole family can enjoy. Truthfully, many

craft beer enthusiasts are at an age where they are becoming parents or have young children. It is as much a smart business decision as it is a matter of culture. The Fort Collins scene is taking a progressive stance on demystifying alcohol consumption and supporting responsible drinkers, today and for the future.

Fort Collins's internal beer community is solid, and its members take that bond into the larger community with volunteer and charitable works. The House that Beer Built began in 2013 through Fort Collins Habitat for Humanity. Craft breweries volunteer time to the build and donate partial proceeds on certain beers in the taproom. Each time a new build is undertaken, usually eight or nine breweries participate at a time. This is just one example of the ways that this industry enriches the surrounding community. Beer festivals and events often have a charitable cause associated with them that focuses on the betterment of the society at large.

Our current society places a lot of emphasis on the process and dogma behind the products that we purchase. We live in a time of farm-to-table restaurants and companies whose purchase of shoes pays for a second pair to be given to an indigent person. In a culture where the almighty dollar is as much a vote for our beliefs as it is a currency, people often struggle to determine what products and companies deserve their market share. Frankly, it can be exhausting. It is comforting to know that the beliefs and practices of these breweries are just as attractive as the delightful beers they produce.

The New Frontier

New Perspective, New Ingredients

The Fort Collins beer culture is united by its principles, but its individual members distinguish themselves with a vast expanse of styles and perspective. This chapter is devoted to elucidating some of the most unique brews in the area. Whether it's the use of ingredients or strange bedfellows, chances are these varieties will not soon be replicated.

The first brewery has carved a niche for itself on the edge of the proverbial cliff, and that's where it likes to be. Black Bottle Brewery is known for a focus on shenanigans, skating culture and an overall irreverent attitude. Owner and brewmaster Sean Nook was a home-brewer in a different career in the late 2000s. While successful in his field, he was unhappy. Those sampling his home-brews were very impressed with the recipes, and this gave him the boost to turn pro. The concept began in 2010, but Nook took his time preparing the brews and brewpub.[88] In December 2012, Black Bottle Brewery opened with forty draft lines and a full-service kitchen. The brewery quickly became known for its knack for experimenting. Some of the most notable styles are the cereal beers. Black Bottle has produced several beers that have kids' sugar cereal added to the brew. Cerealiously Count Chocula is a sweet stout with (you guessed it!) Count Chocula cereal added, marshmallows and all. When it began brewing this, the brewery cleaned out several grocery stores' entire supply of the cereal, much to the disappointment of local youth. Since then, it has been able to buy directly from General Mills. One year, the brewery let the public decide which cereal beer they wanted by way of a bracket

system, à la NCAA's March Madness. The brewery initially offered eight possible choices. Patrons voted, and after several varieties were eliminated, only one cereal beer was victorious.

Black Bottle gained notoriety outside of northern Colorado for its tart cherry and raspberry lambic style called the Last Unicorn. The beer is playfully named after a 1982 animated fantasy film.[89] Most agree that the beer was much better than the film. At 9 percent ABV, it is an unusually high-gravity beer for the style, though it doesn't come across hot. This beer is a fan favorite and makes an appearance from time to time, but, due to the time requirements for aging, it will likely always be a "unicorn" in the taproom.

Snowbank Brewing has taken kettle sours and IPAs to the next level with Skittles Sourado, a special version of its kettle-soured IPA hopped with Apollo and Galaxy hops, with Skittles added. This brew is also somewhat rare, so be sure to call ahead if your heart is set on a sample.

Pateros Creek, open since June 2011, specializes in what it likes to call leisure beers. Bob and Steve Jones, a father-and-son team, started working on the idea of the brewery in 2008. Steve's beer knowledge and Bob's business acumen made them a perfect pair for this venture. Before the brewery opened, they started contract brewing out of Grimm Brothers' facility. Once they secured their space in Old Town, the wheels were in motion.[90]

While the brewery enjoys creating myriad styles, these brews fall into three categories: the Legends, which are the beers that hold a permanent place on the draft list (and in the founders' and customers' hearts); the Renegades, beers that join the party on a seasonal rotation; and the Outlaws, small-batch brews that allow for significant creativity and an opportunity to push the envelope. For the purposes of this chapter, the Outlaws are the focus. Some varieties include Peanut Brittle Red Ale, a beer infused with peanuts and caramel post-fermentation, and Love Blanket, a Scottish ale infused with rose petals, elderberries and orange peel. If something a little safer sounds better, Pateros Creek regularly offers a Porter Float, which is its flagship Cache la Porter with ice cream, whipped cream and chocolate sprinkles.

Not all innovation comes via unusual ingredients. Horse & Dragon opted for a most unusual collaboration in 2016. It brewed with a Fort Collins band called I Am the Owl.[91] The group requested a saison that would be released in conjunction with a concert on October 27, 2016. Linsey set out to make the brewery's first saison, using French Saison yeast, Belma hops and local Troubadour malt. The band joined her on brewing day. The brewery also did a collaboration with local distiller Feisty Spirits

called Feisty. The beer was a blend of three unique beers aged in three different used Feisty barrels. The result was a delightful peach-brandy-infused pale ale.

While these beers are fun to discuss and sample when available, they are merely a few examples in a community willing to push the envelope, try new ideas and not take itself too seriously. Beer is serious business in many ways, but a certain amount of levity is necessary to stay fresh and to continue to capture the attention of the beer consumer, especially in a market full of novelty.

While this book is primarily a look at the breweries of Fort Collins, that doesn't fully encapsulate the complete Fort Collins beer culture. The breweries have created a beer culture that resulted in some spectacular tap houses. Russ Robinson opened a little deli and butcher shop back in February 2004 called Choice City Butcher and Deli.[92] The unpretentious restaurant began with a love of the city's craft beer and some incredible food. Today, it has thirty-five draft lines featuring a wide array of craft beer from all over the country. What separates this place from the others is the food. The butcher shop offers an impressive assortment of meat, such as specialty sausage, wild game and buffalo carpaccio; many options are available for in-house dining. Not a fan of omnivorous dining? Choice City has many vegetarian options on each of its menus. The restaurant is open for breakfast and lunch seven days a week and dinner Thursday through Sunday. Located on the ground floor of the Armstrong Hotel, this unassuming spot is easy to miss as a visitor. This would be a mistake. Choice City was listed in RateBeer's top restaurants for beer in 2010 and 2011 (no. 12 and no. 9, respectively). Today, it is the highest-rated destination in Fort Collins (and one of the highest-rated in Colorado) on RateBeer, with a 97.[93]

Another popular tap house and restaurant is the Mayor of Old Town. Kevin and Barb Bolin were Fort Collins real estate agents who decided to sell their firm and spend their days traveling, searching for a new town for the next chapter of their lives. They did travel, but realized they were pretty happy with what Fort Collins had to offer. What they did encounter in their travels was a multitude of breweries and beer bars. They quickly realized that it seemed strange that a beer-centric place like Fort Collins didn't have something that resembled what the rest of the country was doing. Before they left, Kevin was a fixture in Fort Collins and received the nickname "the Mayor" from some of the locals, which resulted in the name of the bar. They acquired an existing building at 632 South Mason Street that had seen many uses since it was built in 1988. After a remodel, the

first and only local beer bar in Fort Collins was born. It had one hundred draft options. It hit the ground running, with several accolades in 2012 from *Playboy*, *Draft* magazine and Craftbeer.com.[94] While the Bolins love supporting the local craft beer scene, the draft list is filled with options in styles and countries. The aim seems to be for a more global perspective of beer, without alienating local or macro drinkers along the way. Some draft options aren't actually beer; "the Mayor" has been known to offer ciders and meads on tap, as well. Food options are generally elevated pub fare, with some salads and sandwiches available.

The previously mentioned Beer Bettys meet here every Tuesday night. This women's beer club is free to attend and focuses on education and fellowship. The group often features guest speakers in the first thirty minutes of the meeting. Beer flights are available at discounted rates during the event. Sometimes, the club takes it on the road for local brewery field trips. More information is available on the Mayor of Old Town's website (www.themayorofoldtown.com).

It is clear that Fort Collins has its own unique feel and will continue to manifest that spirit in new and innovative ways well into the future.

The Expanding Landscape and the Future of Craft

When it comes to great beer, Fort Collins is not alone in northern Colorado. Many breweries of varied sizes live within thirty miles of Fort Collins in Longmont, Berthoud and Loveland. There are many great breweries emerging from this area, more than can be discussed here. The landscape will likely keep growing and changing faster than anyone can keep up with. Some of the larger breweries may be familiar names, but there are many smaller businesses that may not have the size and distribution to garner such attention.

Just about thirty miles away in Longmont resides Left Hand Brewery. The brewery was named after a Southern Arapahoe chief named Chief Niwot ("Left Hand") who lived in the Boulder Valley. The brewery opened to the public in January 1994, premiering with Sawtooth Ale, an amber ale it still brews today. More than twenty years later, Left Hand distributes to thirty-seven states and several countries and is the thirty-ninth-largest craft brewery in the nation. It was the first brewery to bottle a nitrogen-carbonated beer with Milk Stout Nitro. Today, it has a series of Nitro bottles available. Because it founded this nitro-bottle technology, most people didn't know how to properly pour the beer into a glass to capitalize on that beautiful, creamy head that nitrogen beers are famous for. So, it started a slogan: Pour Hard. Anyone who has been educated on how to pour a beer properly will find this counterintuitive, which is why it required some teaching. Basically, to properly pour a Left Hand Nitro into a glass, one must first remove the cap from a well-chilled beer (40 to 45 degrees Fahrenheit), then pour the beer straight into the glass at a 180-degree angle. The beer will sputter from

air entering the bottle, but it will produce a head akin to that of a nitrogen draft system. It is truly a thing of beauty. (Note: make sure your glass can hold at least sixteen ounces, or your magic trick will quickly become a mess on the floor.)

In 2015, Left Hand followed in the footsteps of New Belgium and Odell by becoming an employee-owned company.[95] The similarities don't end there. Left Hand Brewing has a charity known as the Left Hand Brewing Foundation. For twenty years, this organization has worked alongside the Longmont Community Foundation to support a wide variety of causes in the community and throughout the country. It hosts several events every year to raise money for charities ranging from Bike MS to Meals on Wheels. The most popular of these events is Nitrofest, a relatively new beer festival that celebrates nitrogen beers every November. The event features nitrogenated beer from around forty craft breweries nationally. The evening is about great beer and live performance art. Left Hand has also been a longtime supporter of green energy and conservancy. In 2006, it added photovoltaic solar panels to the building and added an energy-efficient BrauKon kettle in 2011.[96] It is constantly striving for energy efficiency and heat and water conservancy. Beyond this, it is transparent in its numbers. The company displays several graphs on the website comparing its number against the national average. Most of the time, it is better. Sometimes, it isn't, but it is working toward it. The measure of success isn't always being the best. It's about wanting to be, and working toward that goal.

Oskar Blues' current brewery is also in Longmont. Founded in 1997, this brewery's claim to fame was its exclusive use of cans, which it started producing five years later. It can truly be counted as one of the trendsetters in this regard. At the time, some beer purists thought drinking out of cans was gauche, or that any "real" craft beer is bottled. Today, enthusiasts realize the benefits of cans for beer protection and convenient transport. Over time, the company outgrew its small brewery in Lyons, Colorado, and opened the current Longmont location in 2008. It is famous for such beers as Dale's Pale Ale and Old Chub, a wee heavy. The roster has expanded to fourteen selections, including Beerito, an amber Mexican-style lager. This is not your standard pilsner; Beerito is made with a combination of German- and Colorado-sourced malts and is closer to a Vienna lager (a style that Mexican breweries have adopted) with an amber hue. The beer is rich and complex, especially for its 4 percent ABV, with notes of honey and walnut. Another favorite is Death by Coconut, an Irish porter infused with liquid cacao and coconut. An annual winter treat, this semi-sweet porter is infused with liquid cacao from a Colorado company called Cholaca. Care to drink your dessert? This beer is creamy, decadent and has a solid coconut flavor.

This company has expanded in more than just beer offerings: it now has five restaurants, or fooderies, as it refers to them, and two other breweries outside Colorado.[97] Oskar Blues Grill & Brew opened in Lyons, Colorado, in 1997. The original location is still open today, and it still does a little brewing there, too. If experiencing the source is part of your beer travel goals, then take the trip. The brewer's concept has an irreverent feel, from adult big wheels at the Longmont taproom to thinly veiled stoner references in its marketing material. The place is all about having fun. It seems to be working. With some solid beer offering and a playful attitude, the company has expanded into two more breweries: one in Brevard, North Carolina, and another in Austin, Texas.

Longmont isn't home to just the bigger guys. In fact, little Wibby Brewing joined the party in September 2015, making it one of the newest kids on the block. This brewery is doing something very rare for the northern Colorado scene: it produces all lagers, all the time. This brewery has wasted no time getting on its distribution game. It is already canning and some of its products are available at retail location as far south as Thornton, Colorado (at the north end of what is largely considered the Denver metro area). If you prefer to gather your beer at the source, visit Wibby any day of the week. Brewery tours are scheduled for 3:00 p.m. on Fridays, Saturdays and Sundays. Can't make the weekend? Ask someone if you can take an impromptu tour; if they have the staff and it's not busy, they'll be happy to oblige.[98]

Wibby has established itself as a dog-friendly venue. This is also an unusual stance for breweries, not because brewers don't like dogs, but some county and city ordinances forbid our furry friends from tagging along. The taproom offers nonalcoholic options and generally hosts food trucks in the latter part of the week after 4:00 p.m. Wibby has lots of activities, from beer trivia to a corn hole league. It's never a dull moment.

Loveland is home to the Grimm Brothers Brewhouse, founded by Aaron Heaton and Don Chapman. The Colorado natives were home-brewers and met at Liquid Poets. They bonded quickly over their shared interest. They opened Grimm Brothers in 2010 with German styles on the menu. Each beer is named for a different Grimm Brothers fairy tale, many of which are quite dark and fantastic. There are 252 stories, so the founders won't run out of inspiration anytime soon. Many of the beers they brew are rare and nearly extinct German styles. The business continues to expand quickly—it is already bottling, canning and distributing regionally. Aaron Heaton told a great story to Andra Zepplin of Eater Denver about their experience with Fort Collins's famed beer community:

A History of Brewing on the Front Range

When we first started we were going to rent kegs from this one guy, we were cash strapped. So it's Thursday night, we are opening Saturday and we call the guy up and say where are you. Midnight goes by and he's a no show. So we contact Odell and New Belgium and we say hey listen we have 16 kegs to our name, can we rent kegs from you. Both of them said you don't have to rent we are going to let you borrow them.

They entered the Great American Beer Festival for the first time in 2014 and took a gold medal for Little Red Cap, an altbier.[99]

The Grimm Brothers taproom is located at 623 North Denver Avenue in Loveland, just across the parking lot from the brewery. Brewery tours are available every Saturday at 4:00 p.m. for those interested in checking out the ten-barrel system and seeing how this modest brewery is able to produce such varied and interesting beers. The taproom features an ever-changing list of Grimm favorites, but if something a bit rarer is desired, one can opt for a trip on Firkin Fridays. All firkins are cask conditioned and entirely unique (and limited) creations. Either way, stop by the taproom. Owner Aaron Heaton is often there; he loves to share his extensive knowledge and engage in craft beer conversation.

Loveland is also home to Loveland Aleworks. Owner and brewer Nick Callaway did not want his new brewery, born on the Fourth of July 2012, to be beholden to a particular style or flavor profile. He brews a variety of beer that speaks to him and appeals to his fans. That being said, the brewery does have one restriction: it only produces ales, so don't expect a crisp pilsner or marzen on the menu. The brewery and taproom are adjacent in Loveland's downtown area. The brewery holds true to its desire to produce a variety of options, such as an IPA, a saison and even some kettle sours. The brewery seems to have an affinity for Belgian styles as well. In November 2016, Loveland Aleworks released its first barrel-aged bottle, Colorado Grand Cru. This abbey-style ale was aged for sixteen months in red wine barrels, two French oak and three American oak barrels. While this is the company's first foray into cellar beers, it will likely not be its last.

Loveland Aleworks enjoys giving back to charitable causes in the area. On a few Wednesdays each month, it has an event called Pints for the People.[100] This event donates one dollar of every pint sold to local charities, such as Look Both Ways, an organization that educates young people about reproductive health, and High Plains Environmental Center, a nonprofit that works with businesses and builders to create sustainable living and eco-friendly solutions. The chosen charities are posted on the website ahead of the event, allowing the public to decide which causes suit them best.

Verboten Brewing of Loveland may be one of the smallest breweries discussed in this book. Verboten, whose name is a German derivative of

"forbidden," opened in early 2013 with a three-barrel system just across the street from where Dancing Pines Distillery resides in downtown Loveland. Despite a small brewing system, this brewery is producing an impressive variety of beer. Its tap list often includes IPAs, stouts and the like, but it also experiments with styles that are not often seen in this region. For example, Angry Banjo is classified as a Kentucky common, which can best be described as a dark cream ale. The style was popular in Louisville, Kentucky, in the late nineteenth century, but it hasn't really emerged west of the Mississippi River since. Some upcoming beers slated for late 2016 and early 2017 are German Chocolate Cake Stout, an imperial milk stout with coconut and pecans added, and Maiden in the Woods, a Zinfandel barrel-aged imperial saison.

The sense of Fort Collins community is alive with Verboten; they have worked on a collaboration with Peter Bouckaert, New Belgium's head brewer. The beer is called IDEFIX and is a pilsner with a blend of German, Belgian and American malts, then hopped with Saaz, Liberty and Apollo hops. It is expected to make its debut in early 2017 and should be a beer worth traveling for. Verboten is not staying safe in its style and craft choices, which means the public has something new to look forward to every Friday for the foreseeable future.

Berthoud is a small town, even by northern Colorado standards. With a bit more than fifty-one hundred residents, it is a quiet, pastoral area. It would be easy to miss this little stop, but it would be a mistake for the beer explorer, for this town gets to claim City Star Brewing. The company was founded by John and Whitney Way in 2011. John started as a home-brewer and became interested enough in going professional that he took a position at Oskar Blues. Whitney's family was starting a business and bought a very large building on Mountain Avenue in Berthoud. The family didn't need all the space, so they offered a portion of it to house a brewery of their own. It was built in 1915 and was originally the City Star Barn Livery Stable, hence the brewery's name. The young couple had a building and a few recipes, but little else to prepare them. So began a crash course in entrepreneurship! The space needed a complete overhaul. The taproom décor is warm and inviting and at the same time pays homage to the long, rich history of the building. The brewery opened with a handful of mainstays. The original lineup is full of well-balanced, approachable beers, the kind of menu that can be enjoyed by beer geeks seeking out new destinations and local residents who just want to grab a cold pint after work. The brewery actually had to shut down a week after opening, because it ran out of beer! It was evident; Berthoud was thirsty for what City Star had to offer.

Storefront and sign for City Star Brewing, located at 321 Mountain Avenue in Berthoud, Colorado. *Gus Hoffman.*

Over time, the company has expanded its brew system to keep up with demand. Expansion continues with a barrel-aging program. City Star works with a Denver-based barrel broker and has a wide variety of barrels: tequila, rum, Cabernet Sauvignon, whiskey and others. Sometimes, the brewers are fortunate enough to work directly with other local businesses, such as the winery and a few distilleries. The first barrel-aged release was Outlaw, an imperial stout aged in whiskey barrels for one year. The beer quickly gained notoriety and is now an annual release in March. Another product of the barrel-aging program is Buccaneer, an American strong ale brewed with wildflower honey and aged for six months in rum barrels.

Bottled in twenty-two ounce bomber, at 12.6 percent ABV, it pairs well with a friend to help drink it. Aromas of vanilla and caramel begin this sensory experience, followed by a solid brown strong that becomes sweet after about ten seconds on the palate. The flavor is rounded out by a nice, warm alcohol finish. In addition to barrel aging, City Star started pitching wild yeast beer about three years ago. It is remarkable that the brewery is able to produce inoculated beers in the same relatively small space. It is a testament to the workers' meticulous cleaning and sanitizing efforts.[101]

Another sort of expansion is currently underway as the company is remodeling another portion of the ten-thousand-square-foot building, to be used as taproom space, an additional barrel-aging room, office space and a back patio/biergarten for live music and sipping suds in warm weather. City Star is eager to have more space to accommodate its ever-growing fan base and to have room for educational events like beer and food pairings and for meetings of the local home-brew association, known as the Berthoud Barnburners. The project is expected to be completed in the spring of 2017.[102]

Aerial view of Fort Collins's Old Town Square. *Author's collection.*

What Is the Future of Fort Collins Craft Beer?

After speaking to many members of this exceptional community and posing this question, the answer is deceptively simple: more of the same. New breweries will continue to open at a stunning pace. They will either enrich the community or, likely, not last long. This is the reason the breweries don't outwardly compete with each other: with every great new brewery, with every brilliant innovation, Fort Collins gets better. So do the established breweries. They derive inspiration from the expanding horizon. Some breweries will outgrow their current homes; others will be content to stay in their spaces and think of wild new ways to entertain themselves through beer. Thanks to the efforts of this community, this much can be predicted: in Fort Collins, the water will stay pristine, the air will continue to be thin and crisp, and we will always be able to find a great beer.

Fort Fun Festivals and Events

A Guide

This section is designed to be a quick guide to annual Fort Collins beer festivals and tips for navigating the city safely while visiting breweries. Here are some inexpensive ways to get around the city. Please note, operating any vehicle, including bicycles, with a .08 percent blood alcohol content or higher can result in a citation of driving under the influence in the State of Colorado. Stay safe, friends.

Fort Collins has a bicycle rental program throughout the city called Bike Share. Experience the city like a local by enjoying the scenery and extensive bike paths. The purchase of a daily, weekly or annual pass includes unlimited free rides of thirty minutes or less. Rides over thirty minutes are charged an additional two dollars per hour. The maximum charge allowed in a twenty-four-hour period is eighteen dollars, in addition to the cost of the pass. Colorado does not have a helmet law, but if a helmet is desired, it can be purchased for five dollars at the Downtown Transit Center at 250 North Mason Street. Maps are also available at this location. For additional information, check the website at www.bikefortcollins.org.

If you are planning a day of brewery hopping or going to an all-day festival, Fort Collins has a clean, effective and inexpensive bus system. TransFort is available throughout the city ($1.25 for individual rides or $3 for a daily pass). This system includes a line called MAX. This route traverses the city on a dedicated street that runs parallel to College Avenue (the main north–south street). Because there is no traffic on this line, it is an excellent and efficient way to get around, particularly if it's a festival day. MAX passes are also $3/day

and available via kiosk at every stop. Schedules, additional fare information and routes are available on the website www.ridetransfort.com.

Annual Festival Schedule

Times are approximate, as exact dates change from year to year.

Fort Love Brewers' Jamboree (May)

The season kicks off with one of Colorado's best festivals. Fort Love Brewers' Jamboree is still small and focuses on beer education. Brewers are often at their tents and ready to talk beer with the crowd. This is the kind of festival beer geeks wish all festivals imitated. Premiere Pass holders get one-hour early admission. Tickets go quickly, so advance purchase is encouraged.

Tickets: $45 general admission, $70 Premiere Pass. www.brewersjamboree.com

Fort Collins Beer Week (June)

Fort Collins Beer Week is the ultimate Fort Collins beer experience. In 2016, there were nearly forty official events scheduled over eight days. Breweries will be touting their favorites, and local restaurants and pubs will likely have special tappings to celebrate. While there are too many events to mention, what follows are some highlights.

Brewers Olympics begins the celebration on the Saturday prior to beer week. This is a ten-dollar, all-ages event. The entrance fee includes one beer token and fabulous tchotchkes. The proceeds go to the House That Beer Built. Watch as local breweries engage in ridiculous feats and goofy competitions, vying for the next year's bragging rights. Olympic-themed costumes are encouraged. Additional beverages and food are available for sale. Oh, and they have brewer dunk tanks.

Colorado Brewers Festival is the culmination of all the week's fun. Event entry is free, but a taster package is required to enjoy beer. Tickets are twenty-five dollars in advance at a local participating brewery, thirty-five dollars at the gate and include the glass and ten taster tickets. Additional tickets may be purchased. The event has music, demonstrations and over ninety beers from more than forty Colorado breweries. The event is held in Washington Park in downtown Fort Collins. More information can be found at www. fortcollinsbeerweek.com.

Fort Fun Festivals and Events

Tour de Fat (September)
Tour de Fat takes the party on the road and makes stops in several American cities, but if you want to experience the party where the party started, this is the place. New Belgium has been hosting this event for seventeen years. It is a day filled with music, games, a bike parade and spectacular beer. Entry is open to all ages and is free, but donations are accepted for local charities. Costumes are encouraged—the wackier, the better! Beers costs five dollars, food ranges from five dollars to ten dollars. The event takes place in Civic Center Park in Fort Collins. Entrance is free. More information is available at www.newbelgium.com/Events/tour-de-fat/Fort-Collins.

FORToberfest (September)
This is the last outdoor festival of the year, due to weather expectations. It is a ten-hour music festival featuring local seasonal beers. It takes place in Old Town Square in Fort Collins. Entrance is free. More information is available at http://downtownfortcollins.com/events/fortoberfest.

Notes

CHAPTER 1

1. "History," Visit Fort Collins, accessed June 2016, http://www.visitftcollins. com/about-fort-collins/history.
2. Ibid.
3. Erin Udell, "Laws and Liquor: FoCo's Alcohol-Free Years," Collegian. com, February 2, 2011, accessed June 2014.
4. Ibid.
5. "Why Did Colorado Suffragists Fail to Win the Right to Vote in 1877, but Succeed in 1893?" Women and Social Movements in the United States, accessed June 2014, http://womhist.alexanderstreet.com/colosuff/intro. html.
6. "Fort Collins Time Line 1890," Fort Collins History Connection, accessed June 2014, http://history.fcgov.com/archive/timeline/1890.php.
7. Ibid.

CHAPTER 2

8. "10 Things You Should Know About Prohibition," History, January 15, 2015, accessed June 2016, http://www.history.com.
9. Juszak, Lori, *Ghosts of Fort Collins* (Charleston, SC: The History Press, 2012), 78

10. "10 Things You Should Know About Prohibition."
11. Erin Udell, "A Look Back: Fort Collins' Long-Lived Prohibition," *Coloradoan*, April 17, 2016, accessed June 2016, http://www.coloradoan.com.
12. Randy Mosher, *Tasting Beer: An Insider's Guide to the World's Greatest Drink* (North Adams, MA: Storey Publishing, 2009), 24–25.
13. Ibid., 22
14. Molly Kunst of FleishmanHillard, public relations for Anheuser-Busch, e-mail interview with the author, October 13, 2016.
15. Ibid.
16. Dave Iverson, interview with the author, October 18, 2016.
17. C.B. & Potts: Our Awards, accessed October 18, 2016, http://www.cbpotts.com/our-awards.

Chapter 3

18. Brandon Neckel, interview with the author, October 7, 2016.
19. Ibid.
20. Ibid.
21. Josie Sexton, "CooperSmith's: The Hub of Brewpubs in Fort Collins," *Coloradoan*, February 13, 2014, accessed November 17, 2016, http://www.coloradoan.com.
22. Ibid.
23 Ibid.
24. CooperSmith's Pub, accessed November 17, 2016, http://coopersmithspub.com/beer.

Chapter 4

25. Doug Odell, interview with the author, July 16, 2016.
26. Ibid.; Holly Engelman, "Q&A with Wynne Odell," *Coloradoan*, November 5, 2015, accessed July 12, 2016, http://www.coloradoan.com.
27. Ibid.
28. "Our Story," Odell Brewing Company, accessed July 2016, http://www.odellbrewing.com/our-story.
29. Jeremy Myers, "Odell Releases Beer to Raise Awareness and Funds for Study of Rare Colorado Butterfly," *Denver Post* blogs, May 3, 2013, accessed July 2016.

30. Sam Gaver, phone interview with author, August 2016.

31. Pat Ferrier, "Odell Moves to Employee Ownership," *Coloradoan*, July 20, 2015, accessed July 2016, http://www.coloradoan.com.

32. Marni Wahlquist, interview with author, September 16, 2016.

33. Ibid.

34. "Sustainability," Odell Brewing Company, accessed September 2016, https://www.odellbrewing.com/sustainability.

35. Ibid.

36. Wahlquist, interview.

Chapter 5

37. Recorded by author on the New Belgium tour with David, September 17, 2016

38. Ibid.

39. Ibid.

40. "Company History," New Belgium Brewing, accessed September 2016, http://www.newbelgium.com/Brewery/company/history.

41. "What Are B Corps?" B Corporation, accessed September 2016, https://www.bcorporation.net/what-are-b-corps.

42. New Belgium tour, recording.

43. Bryan Simpson, interview with the author, September 16, 2016.

44. "Sustainability," New Belgium Brewing, accessed September 2016, http://www.newbelgium.com/files/sustainability/New_Belgium_Sustainability_Brochure.pdf.

45. Simpson, interview.

46. Ibid.

47. "La Folie," New Belgium Brewing, accessed September 2016, http://www.newbelgium.com/Beer/la-folie.

48. New Belgium tour, recording.

49. Ibid.

50. "Transatlantique Kriek," New Belgium Brewing, accessed September 2016, http://www.newbelgium.com/Beer/transatlantique-kriek.

51. "We're Brewing Another Beer with Ben and Jerry's," New Belgium Brewing, accessed September 2016, http://www.newbelgium.com/community/Blog/new-belgium-brewing/2016/06/20/we're-brewing-another-beer-with-ben-jerry's.

74. "About Us," Rally King Brewery, accessed December 16, 2016, https://rallykingbrewing.com/about-us.
75. Three Four Beer Company, accessed December 16, 2016, http://www.threefourbeerco.com.
76. Wiley Gellar, phone interview with the author, December 18, 2016.
77. Joey McClellan, phone interview with the author, December 16, 2016.

Chapter 8

78. "Anheuser-Busch and The Nature Conservancy Partner to Improve Fort Collins Watershed by Reducing Risk of Megafires," The Nature Conservancy, June 5, 2015, accessed November 2016, http://www.nature.org/ourinitiatives/regions/northamerica/unitedstates/colorado/newsroom/colorado-fort-collins-partnership-with-anheuser-busch.xml.
79. "Climatewise," City of Fort Collins, accessed September 2016, http://www.fcgov.com/climatewise.
80. Anheuser-Busch Fact Sheet, published January 8, 2016, accessed November 2016.
81. Joshua M. Berstein, "2016 Beer Person of the Year: New Belgium's Lauren Woods Salazar," *Imbibe* magazine, accessed November 2016, http://imbibemagazine.com/new-belgiums-lauren-woods-salazar.
82. Pink Boots Society, accessed September 2016, https://www.pinkbootssociety.org.
83. Cochran, interview.
84. Liquid Poets, accessed November 2016, http://liquidpoets.com.
85. Colin Westcott, phone interview with the author, December 16, 2016.
86. Erin Udell, "Breweries Get Family Friendly in Fort Collins," *Coloradoan*, February 18, 2016, accessed December 11, 2016, Coloradoan.com.
87. Ibid.

Chapter 9

88. Sean Nook, interview with the author, September 16, 2016.
89. Ibid.
90. Pateros Creek Brewery, accessed November 15, 2016, http://pateroscreekbrewing.com/pcbc/history.

91. "Special Batch Beers," Horse & Dragon, accessed November 15, 2016, http://www.horseanddragonbrewing.com/special-batch-beers.html.

92. Matthew Curtis, "Pulling Everything Together—Beer and Community in Fort Collins, CO," Good Beer Hunting, April 13, 2016, accessed December 10, 2016, http://www.goodbeerhunting.com.

93. "Fort Collins," RateBeer, accessed December 10, 2016, https://www.ratebeer.com/places/city/fort-collins/6/213.

94. "About," Mayor of Old Town, accessed December 11, 2016, http://themayorofoldtown.com/about.

Chapter 10

95. "History," Left Hand Brewing Company, accessed November 16, 2016, http://lefthandbrewing.com/about/history.

96. Ibid.

97. "About Us," Oskar Blues Brewery, accessed November 16, 2016, https://www.oskarblues.com/aboutus.

98. "Wibby Taproom," Wibby Brewing, accessed December 11, 2016, http://www.wibbybrewing.com/wibby-taproom.

99. Andra Zeppelin, "Telling Stories: Grimm Brothers Brewhouse," Eater.com Oct 14, 2012. Accessed November 16, 2016.

100. "Upcoming Events," Loveland Aleworks, accessed December 11, 2016, http://www.lovelandaleworks.com/upcoming-events.

101. Whitney Way, interview with the author, September 17, 2016.

102. Ibid.

Index

INDEX

About the Author

Brea D. Hoffman has been a Colorado resident for twenty-five years. She attended Colorado State University in Fort Collins. A couple of the beers that forever changed the way she thought of the libation were Hanssen's Oud Kriek and New Belgium's 2003 Love. Life would never be the same. In the early 2000s, she wrote an entertainment column for the *Denver Daily News*. She is a level II executive sommelier through the International Wine Guild, a certified beer server through Cicerone and is working toward her certified cicerone. She has worked in the hospitality and alcoholic beverage industry since 2011. She currently lives outside of Durango, Colorado. This is her first book, but she hopes to continue to write and educate people about beer and wine for many years to come.